REMBRANDT IN PRINT

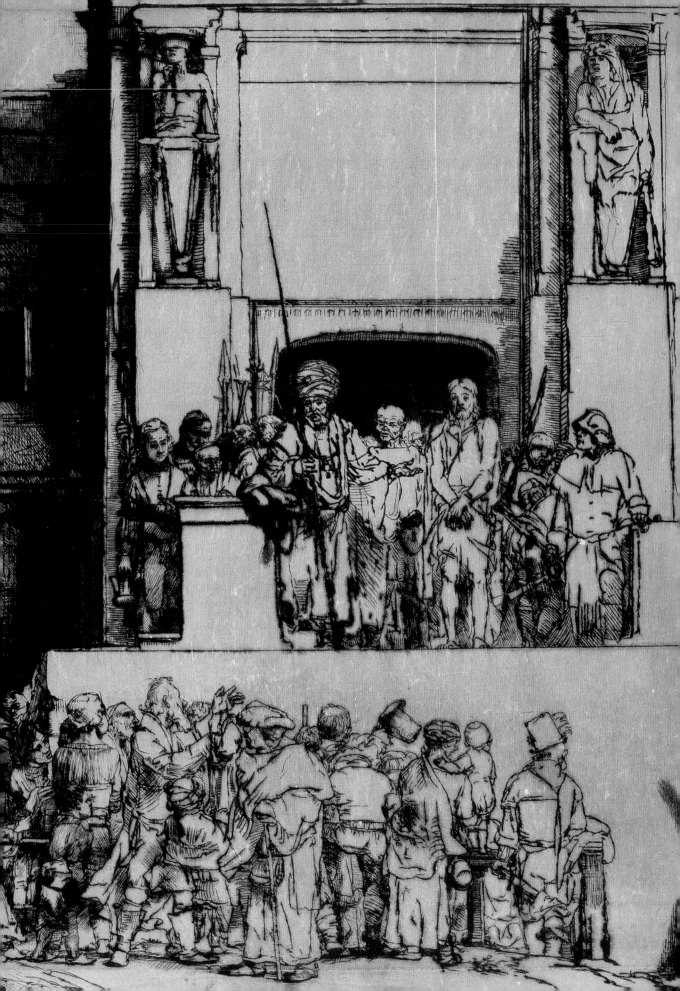

REMBRANDT IN PRINT

An Van Camp

ASHMOLEAN

Published by the Ashmolean Museum, University of Oxford
Designed and typeset in Adobe Garamond Pro by Stephen Hebron
Printed and bound in Great Britain by Short Run Press Ltd

Front cover: *Self-portrait Etching at a Window*, 1648
Back cover: *The Three Trees*, 1643

ACKNOWLEDGEMENTS
Chiara Betti
Catherine Bradley
Mark Carnall
Lara Daniels
Alexandra Greathead
Stephen Hebron
Hannah Manson
Declan McCarthy
Caroline Palmer
Beth Twinn
Catherine Whistler
Katherine Wodehouse

For further details of Ashmolean titles please visit:
www.ashmolean.org/shop

CONTENTS

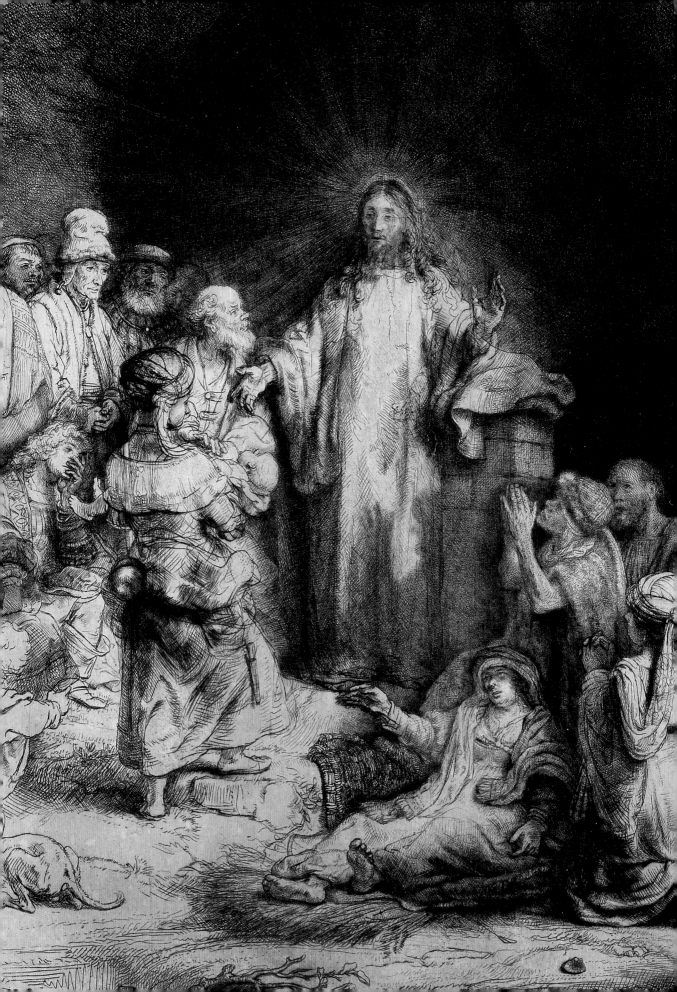

INTRODUCTION

The Ashmolean Museum, University of Oxford, holds a world-class collection of works on paper which can be admired in the Museum's Western Art Print Room free of charge and on a walk-in basis. Containing nearly 300,000 prints and drawings ranging from the fourteenth century until the present day, the works by the most famous Dutch artist of all time, Rembrandt van Rijn (1606–1669), rank among the most impressive in the collection. These twenty drawings and over two hundred prints span Rembrandt's entire career, from his earliest works made in his hometown of Leiden to his latest made in Amsterdam, where he would die in 1669. Over the past four centuries Rembrandt has inspired many exhibitions and 2019 celebrates the Dutch artist in the international Year of Rembrandt on the occasion of the 350th anniversary of his death.

Rembrandt was born in Leiden in 1606 as Rembrandt Harmenszoon van Rijn, son of malt miller Harmen van Rijn and Cornelia 'Neeltgen' Willemsdochter van Zuytbrouck. After a brief stint at Leiden University, Rembrandt enrolled with local painter Jacob van Swanenburg (1571–1638), probably for a period of around three years in which he learned the basics of painting. A more specialised apprenticeship in history painting occurred with Pieter Lastman (1583–1633) in Amsterdam in 1625, after which Rembrandt returned to Leiden to set up an independent workshop. In 1631 Rembrandt moved to Amsterdam to work for the art dealer Hendrick van Uylenburgh (c. 1587–1661), who introduced the talented artist to his wealthy cousin Saskia (1612–1642), and the pair married in 1634. They had a son, Titus, a year before Saskia died in 1642. Lost without his wife and spending his income on an ever-growing collection of art, historical costumes and weapons, antiquities and natural history objects, Rembrandt struggled to pay off the mortgage of their large house in the Jodenbreestraat (the present Rembrandt House Museum). He was declared insolvent in 1656 and, although he was allowed to keep his painting equipment and printmaking tools, suffered heavily, ultimately leading to his death in 1669.

This publication will give an overview of Rembrandt's printed oeuvre, not necessarily in a chronological order but rather grouped by theme. Rembrandt was an unrivalled storyteller, which will be demonstrated through a selection of prints ranging from 1630 until the late 1650s. Moreover, it is through Rembrandt's prints that we can truly look over his shoulder and get to know the artist more intimately. The prints in their varying stages of development allow us to discover the step-by-step processes undertaken by Rembrandt in his workshop. These, combined with self-portraits spanning his entire career, form a printed legacy providing an authentic glimpse into Rembrandt's life and working methods. Uncovering these stories from the Ashmolean's rich collection, this publication presents a selection of around seventy extraordinary Rembrandt prints alongside a handful of related drawings.

REMBRANDT'S PRINTMAKING TECHNIQUES, PAPERS AND INSCRIPTIONS

ENGRAVING

Engraving [fig.1] was the prevalent printmaking technique in the seventeenth century as it was durable and allowed for many impressions to be printed from the copper-plates. It required extensive training and was only done by specialist engravers. The burin, a V-shaped metal tool, is pushed by the engraver into the plate, creating very sharp and regular lines cut into the metal. Rembrandt, however, was a highly experimental printmaker who used a variety of printmaking techniques, such as etching and drypoint, with only the occasional use of the burin for small retouchings to his compositions.

ETCHING

Out of a total of 314 prints attributed to Rembrandt, over 80 copper-plates have survived, the majority of which are etched, a technique that allowed for freer lines [fig.2]. The impressions printed from these plates allow us to examine Rembrandt's printmaking techniques first-hand.

In order to create an etching, Rembrandt covered the copper-plate with a ground, probably a thin layer of soft wax, into which he could easily draw with an etching needle. While drawing the lines of the composition into the ground, the etching needle scratched away the wax, exposing the metal surface of the plate below. The composition had to be drawn in reverse onto the plate in order for it to appear in the correct direction in the final print. Similarly, Rembrandt had to sign the plate in reverse in order for his signature to be legible in the print.

In order to bite or etch the lines permanently into the copper, Rembrandt then needed to treat it with acid or mordant, either by submerging the plate in an acid bath or gently pouring the liquid over the surface. The biting or etching of the plate could be done in one go or in stages, depending on the thickness of the lines Rembrandt wanted to achieve, which would determine the length of time they were exposed to the acid. Once Rembrandt was satisfied the entire composition was sufficiently bitten, the wax layer was removed by heating the plate and pouring off the melted wax. The plate was then thoroughly cleaned, after which Rembrandt rubbed it with a sticky black ink made of linseed oil, making sure the ink only settled inside the etched lines. The plate was then polished with cloths in order to remove the excess ink from the areas which needed to remain blank in the final print. Rembrandt, however, would often experiment by leaving thin films of ink on the plate, called plate tone, in order to create darker compositions.

While most printmakers employed professional publishers to print their copper-plates, Rembrandt probably owned his own printing press. This allowed him to

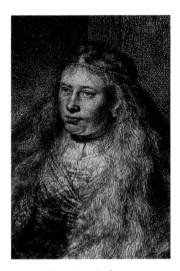

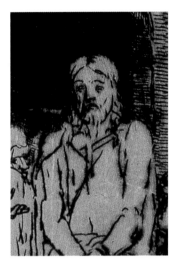

| Fig.1 Detail of no.16 (etching and engraving) | Fig.2 Detail of no.7 (etching) | Fig.3 Detail of no.19 (drypoint) |

experiment freely in his printmaking using different tools and a variety of inking, but often resulted in flawed plates featuring stains and scratches. In order to make an impression of the print, Rembrandt positioned the copper-plate on a rolling press with a damp sheet of paper placed on top of it. The plate and the sheet of paper would then be rolled through the press, firmly pressing the paper into the inked lines of the copper-plate. Once rolled through the press, the paper could be peeled off the plate, revealing the printed image – in reverse to that on the plate. When Rembrandt was satisfied with the printed impression, he would create a larger edition of 20–25 prints. If not, he would continue to make alterations onto the plate, either in etching, drypoint or engraving. Each change made on a copper-plate of which impressions have survived is called a state. Rembrandt's oeuvre is unique in containing impressions of many different states, allowing us to follow his printmaking processes step by step.

DRYPOINT

While the majority of Rembrandt's prints are done in etching, he would also use drypoint [fig.3], either to add small retouchings to his etchings or even to create entire prints. Drypoint was done directly onto the copper-plate with a drypoint needle. The dragging of the needle directly into the copper created ridges on both sides of the scratched line, known as burr. When inked, this burr would collect a lot of ink and result in thick, velvety lines in the impression. Because the burr is raised from the printing surface, it is very delicate and wears down with each printing, resulting in a small number of good impressions. Rembrandt used this technique as early as 1629 for small retouchings, gradually expanding its use. This culminated in the 1650s with Rembrandt creating large plates entirely drypoint, true feats of printmaking.

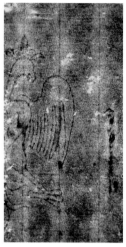

Fig.4 Watermark from no.16 Fig.5 Detail of no.19

SUPPORTS

Rembrandt experimented with different supports on which to print his plates. He most commonly used European laid paper. This was made by scooping paper moulds, sieves made of a fine-metal mesh, through a vat of pulp made from rags, resulting in a fine grid-like texture in the paper. There were no paper mills in the Netherlands and most paper was imported from modern-day France, Germany and Switzerland. Each mill had its own watermark created by forming a wire pattern within the metal mesh mould, thus identifying each mill. These watermarks in Rembrandt's papers allow us to date the printing of his impressions [fig.4].

In addition to European paper, Rembrandt also used Japanese paper imported by the Dutch East India Company, who had gained exclusive access to Japan via the harbour in Nagasaki. Japanese paper was made from mulberry tree fibres with colours ranging from off-white and honey yellow to deep orange [fig.5]. From 1647 onwards Rembrandt preferred its smooth surface for printing drypoint prints as the ink would be crisply retained on the less absorbent surface and did not cause as much damage to the burr.

Rembrandt also printed on vellum (calf skin) which was very expensive, but allowed for larger plates to be printed on a smooth surface. Unfortunately the Ashmolean does not hold any impressions by Rembrandt that are printed on vellum.

INSCRIPTIONS

Rembrandt considered his prints to be works of art in their own right and he often signed them in the same way as his drawings and paintings.

The monogram 'RHL' was used by Rembrandt when he worked in Leiden until 1631, being an abbreviation or monogram of 'Rembrandus Harmanni Leydensis', Latin for 'Rembrandt, son of Harmen, of Leiden' [fig.6].

From 1631 onwards, when he moved to Amsterdam, Rembrandt clearly wanted a different signature to his Leiden monogram. From that time onwards he signed with his first name only: 'Rembrandt' or 'Rembrandt f.', *fecit* being the Latin for 'made it' [fig.7].

Interestingly, Rembrandt would not add other inscriptions such as titles to these plates, not even the names of the sitters in his portrait prints, which was otherwise commonly done in order to identify the portrayed people.

Rembrandt had to scratch his signature in reverse into the etching ground, but would often forget to do this for numbers, resulting in the date being printed in reverse [figs 8 and 9].

Rembrandt rarely wrote on his printed impressions. The impression of *Saint Jerome Reading in an Italian Landscape* bears '7. op de plaat' in red chalk in Rembrandt's handwriting, extraordinarily revealing it was the seventh impression ever printed from that plate [fig.10].

Fig.6 Inscription, no.41

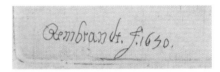

Fig.7 Inscription, no.5

Fig.8 Inscription, no.42

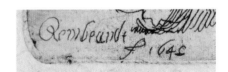

Fig.9 Inscription, no.30

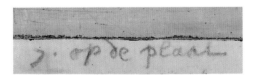

Fig.10 Inscription, no.22

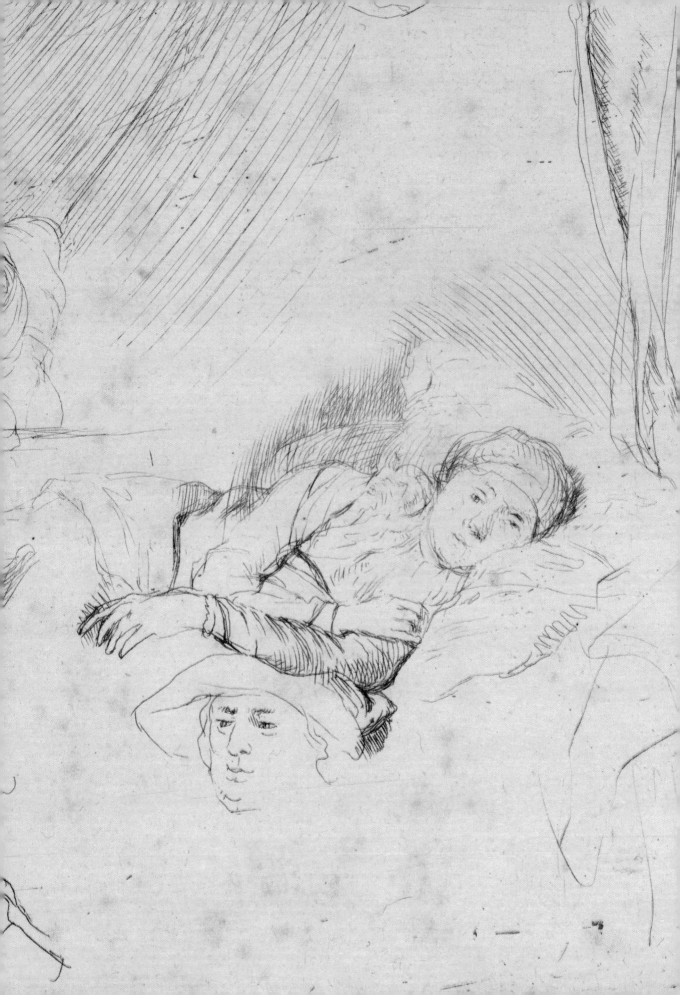

REMBRANDT AS AN OBSERVER OF LIFE

Widely hailed as the greatest painter of the Dutch Golden Age, Rembrandt was also one of the most innovative printmakers of the seventeenth century. While most artists employed professional engravers to create printed reproductions of their paintings, Rembrandt made his own highly original prints as artistic expressions by using traditional printmaking techniques and printing methods in his own innovative way. He never received formal printmaking training and was probably self-taught in etching and drypoint. These printmaking techniques were easier to learn than the more prevalent engraving as they did not require so much technical training. Interestingly, instead of only publishing the finished state of a print Rembrandt would make prints of the intermediary, unfinished stages while working on a copper-plate. While these might appear unfinished, he once remarked that 'a work of art is finished when the intentions of the artist are in it' (Arnold Houbraken, *De groote schouburgh*, 1718, p.259). Through Rembrandt's prints it is therefore truly possible to look over his shoulder and watch the artist at work. By demonstrating step by step how he created these much admired works, he provided a glimpse into his working methods. Rembrandt's prints range from squiggly, drawing-like sketches to more pictorial, heavily-hatched compositions.

INNOVATIVE THEMES

While apparently quite diverse at first sight, all Rembrandt's printed works are characterised by his talent for storytelling and his keen observational skills. He treated all his subjects from a psychological viewpoint, steeped in drama, whether they were intense self-portraits, atmospheric views of the Dutch countryside, confronting nude studies or lively biblical scenes. Rembrandt was highly original in the subjects he rendered in print, not only in the numerous self-portraits showing his personal as well as his artistic development, but also revealing his family life through intimate snapshots. These private insights into the artist's life contribute to his continuing popularity. *Sheet of Studies with a Woman lying ill in Bed* [no.**1**] shows Rembrandt's wife Saskia van Uylenburgh (1612–1642), who died in 1642 from tuberculosis. Rembrandt did not shy away from showing her in such a vulnerable state and the Ashmolean also holds a drawing depicting a very similar scene, loosely drawn in brush and brown ink in an almost calligraphic manner [no.**2**].

While most printmakers only made prints of historical, religious or mythological subjects, Rembrandt, on the contrary, delighted in presenting everyday scenes, often depicting street life such as beggars. *The Bathers* is almost too banal to be rendered in print. It shows a group of men captured in a leisurely activity and is loosely etched, as if Rembrandt had taken his copper-plate outside and sketched this scene on the spot [no.**3**]. Similarly, Rembrandt made prints of more traditional subjects, such as religious scenes, but often presented in an unconventional manner. *The Virgin and*

Child with the Cat and Snake looks like an everyday nursing scene inside a humble setting were it not for the halo surrounding the Virgin's head and the snake at her feet [no.**4**]. *The Shell* is Rembrandt's only still-life print [no.**5**]. Identified as *Conus marmoreus*, the shell depicted probably belonged to Rembrandt himself as he was a keen collector of natural history objects in addition to art, costumes and weapons. His minute attention to detail is only marred by the fact that the coil of the shell is in reverse of its natural appearance as Rembrandt must have drawn it directly onto the copper-plate. *A Scholar in his Study*, later called 'Doctor Faust', is one of Rembrandt's most puzzling subjects and its cryptic inscriptions have yet to be fully interpreted [no.**6**]. A scholar is seen leaning over his desk, seemingly surprised by a shiny apparition in his window composed of concentric circles containing mystical letters and a mirror held by floating hands. The contrast between the sketchy foreground and the densely hatched background draw attention to the bright apparition.

EXPERIMENTAL PRINTMAKER

Apart from his unique treatment of a wide range of subjects, Rembrandt was an experimental printmaker (see pp.8–11). While he used traditional printmaking techniques, he would apply them in an original manner and often combine etching, drypoint and engraving. He would also experiment with different papers and would not be afraid to abandon failed attempts, cutting up the copper-plate to be re-used. For example, the plate for Rembrandt's *Ragged Peasant with his Hands behind Him, holding a Stick* was cut from a larger one showing a kneeling Saint Jerome, whose knuckles are still visible in the lower part of the *Ragged Peasant* plate [no.**7**]. In another example, the copper-plate for *Christ and the Woman of Samaria: an arched print* from 1647 was originally much larger and the portion trimmed off at the top corresponds exactly with the plate for *Nude Woman bathing her Feet at a Brook* from a year later [nos **8** and **49**].

In addition to cutting up plates, Rembrandt would also recycle older ones. *The Shepherd and his Family* is done entirely in etching, allowing Rembrandt to create a composition which resembles a drawing [no.**9**]. Faint geometric circles can be seen in the sky indicating that Rembrandt had probably re-used an older copper-plate for this etching. While other printmakers would have removed these circles first in order to work on a clean plate, Rembrandt did not bother to remove these earlier traces. Similarly, hints of another composition can be distinguished in the clouds in the top left of Rembrandt's *The Three Trees* [no.**10**; fig.11]. Rembrandt must have previously started a scene of *The Death of the Virgin* lying in a four-poster bed on this plate, and after abandoning it used the traces of the older scene to his advantage by turning them into billowing clouds in *The Three Trees* [no.**11**].

Old Man shading his Eyes with his Hand is a great example of an apparently unfinished print by Rembrandt [no.**12**]. Only the head and the left arm of the portrayed scholar appear finished, while the clothes and chair are merely outlined. Rembrandt combined etching and drypoint, whereby the thickly inked drypoint strokes are used for the rich textures of the fur sleeve and the velvet cap, whereas the squiggly etched lines perfectly render the scholar's curly beard. Rather than giving an accurate

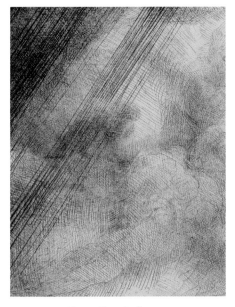
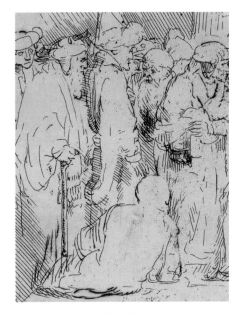

Fig.11 Detail of no.10 Fig.12 Detail of no.13

portrayal of the man, Rembrandt decided to emphasise the scholar's expression; he stares intensely at the viewer while shielding his eyes with his hand, casting his face in deep shadows. Surprisingly, despite its unfinished appearance, this is not a rare print as it has survived in dozens of impressions, indicating that Rembrandt must have been satisfied with it and therefore had it distributed. Another etching, *Christ disputing with the Doctors*, looks even more unfinished with its stippled outlines and the reclining figure in the left foreground which is almost ghostlike. Rembrandt, however, never cared to work out the scene in more detail as no later states are known [no.**13**; fig.12].

Another original aspect of Rembrandt's printmaking is that he created printed study sheets in which he combined several sketches on one plate in a seemingly haphazard way. Particularly curious is *Sheet of Studies with head of the artist, a beggar couple, heads of an old man and old woman* [no.**14**] which features Rembrandt's self-portrait among beggars and peasants. The plate also shows signs of extensive foul biting in the shape of blotchy ink stains where the acid mistakenly penetrated the etching ground. Rembrandt often printed dirty copper-plates, due to faulty acid biting or sloppy printing. *The Virgin with the Instruments of the Passion* [no.**15**] does not have a perfectly white background either but instead features messy streaks, possibly because the etching ground became porous during the acid biting. It is a relatively rare print – only a dozen impressions are known to have survived – so maybe Rembrandt abandoned the plate quite quickly for this reason.

Rembrandt was prolific in his use of the drypoint technique, despite the fact that only a few good impressions could be printed from drypoint plates (see p.9). At the beginning of his career, Rembrandt used it for small retouchings after the plate

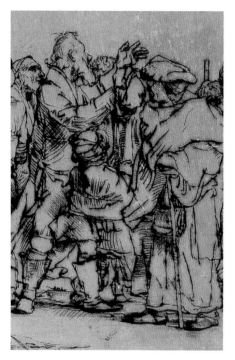

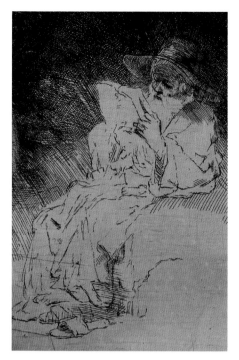

Fig.13 Detail of no.19 Fig.14 Detail of no.22

had been etched, an example being the strokes seen in the face of *The Great Jewish Bride* [no.**16**; fig.1]. From the 1640s Rembrandt would use drypoint more extensively, culminating in a number of plates entirely executed in the medium. The first state of *Clump of Trees with a Vista* [no.**17**] was entirely done in drypoint, probably directly onto the plate in the open air. The landscape appears abstract with some of the trees simply rendered in short strokes. The second state of the same print is more delicately finished but again entirely in drypoint in order to render the foliage of the trees [no.**18**]. Becoming more confident with the drypoint needle, Rembrandt created his largest prints solely in drypoint in the 1650s, *The Three Crosses* and *Christ presented to the People (Ecce Homo)* [no.**19**]. In the latter print Christ is shown on a platform presented by the Roman prefect Pontius Pilate to a group of onlookers. Not entirely satisfied with his composition which placed a barrier between the viewer and Christ, Rembrandt later radically changed his mind and burnished the figures in the foreground, resulting in a heavily scratched plate. Interestingly, Rembrandt made impressions of this damaged plate, probably satisfying a demand from keen collectors who wanted impressions of each state. Only eight impressions are known of the first state before the figures were scratched out, including the Ashmolean's superb impression. These are all printed on Japanese paper, ranging in colour from pale yellow to deep orange for added dramatic effect [fig.13].

Apart from *Ecce Homo*, Rembrandt's most radically altered print is *The Flight into Egypt* [no.**20**]. The large landscape scene with the Holy Family on the move in front of some tall trees on the right was in fact printed from a re-used copper-plate by

another Dutch artist, Hercules Segers (1589/90–1633/40). It is known that Rembrandt was a great admirer of Segers and the reworking of this plate from the original *Tobias and the Angel* into *The Flight into Egypt* must be seen as a tribute. Looking closely at the trees in the top right corner, the feathers of the angel's wings can still be observed.

RELIGIOUS SUBJECTS

The majority of Rembrandt's prints consists of religious subjects and Rembrandt often repeated the same themes. For instance, he made no fewer than seven prints featuring Saint Jerome, possibly as he was fascinated by the solitary hermit weathered by old age and torn by repentance. *Saint Jerome beside a Pollard Willow* is entirely dominated by the prominence of the gnarled tree trunk, which almost hides the saint writing in the background [no.21]. This effect is only strengthened by the drypoint touches on the bark and the lion peeping from behind the tree on the left almost appears to have been added as an afterthought. *Saint Jerome Reading in an Italian Landscape* equally draws attention to the large tree on the left, heavily worked up in drypoint, while the saint is tucked away in the lower corner, only summarily outlined in a sketchy manner [no.22]. As opposed to the lion in the previous iteration of the same subject, here he is standing proudly with the fullness of his mane masterly rendered in drypoint touches. Rembrandt proves himself an excellent observer by showing Saint Jerome casually reading a book, having kicked off his sandals first [fig.14].

Rembrandt also favoured night scenes in order to exploit the *chiaroscuro* effect, the dramatic contrasts between light and dark. His first nocturne, *The Angel appearing to the Shepherds*, made in 1634, acquainted Rembrandt with the tonal possibilities of etching [no.23]. Unlike his typical drawing-like style, Rembrandt explored the use of extensive hatching and even left a thin layer of ink on the plate during printing, called plate tone, in order successfully to enhance the nocturnal setting. Rembrandt's passion for *chiaroscuro* reached its height in the 1650s when his night scenes are steeped in almost complete darkness, often with only a single light source. Great examples are *The Star of Kings* and *The Flight into Egypt: a night piece*, both made in 1651 and appearing almost black, only lit respectively by the star of the Epiphany procession taking place and a lantern held by Saint Joseph [nos 24 and 25]. It is impressive that – although these compositions are so heavily hatched and inked – their details become discernible after close inspection and slowly reveal their contours and shapes. In *The Descent from the Cross by Torchlight*, it is clear that Rembrandt experimented with excessive plate tone during inking, resulting in a stunning, atmospheric impression [no.26].

In the large etching of *The Death of the Virgin*, Rembrandt reached a greater variety of line and tone. The angels at the top are loosely sketched while the figure at the table in the left foreground and the curtains in the background are more heavily worked out in cross-hatching [no.11]. The dying Virgin herself is delicately rendered with a few finely etched lines. While in principle a solemn scene, Rembrandt subtly imbued it with movement through the doctor taking the Virgin's pulse, Saint John spreading his arms in agony and more mourners pouring through the open curtains at far right. Made shortly after *The Death of the Virgin*, *The Presentation in*

the Temple is similar in its combination of heavy cross-hatching and barely etched portions [no.**27**]. However, despite the mysterious light diffused in the temple, it lacks somewhat in contrast. Rembrandt tried to enhance this in the second state by strengthening some outlines in drypoint and for instance placing a skull cap on the head of Simeon who is holding the Christ Child at centre [no.**28**; fig.15].

Another beloved subject of Rembrandt was *The Raising of Lazarus*, which he etched twice. The earliest and largest version was made around 1632 in relation to a painting depicting the same subject [no.**29**]. The arched composition, ostensibly surrounded by a picture frame, reveals a dramatic scene with expressive hand gestures and faces, steeped in strong light contrasts. This was followed ten years later by a much more introspective interpretation of the same biblical story. *The Raising of Lazarus: small plate* of 1642 is in fact dominated by Christ calmly raising his hand and an abundance of white background [no.**30**].

Being one of Rembrandt's most ambitious and complex etchings, *Christ healing the Sick* from around 1648 is often considered Rembrandt's masterpiece, combining etching, drypoint and engraving, in addition to displaying a variety of tone and textures. Its common name, *The Hundred Guilder Print*, derives from the high price that this print already fetched during Rembrandt's lifetime, testimony of its qualities [no.**31**]. While the left portion is bathed in light and barely sketched, the composition becomes darker towards the right with the camel barely visible. The scene does not refer to a specific episode of Christ's life and different groups of figures can be isolated and appear to form their own stories, such as the elderly men in the upper left, deep in discussion among themselves and not really paying attention to Christ [fig. 16]. Strangely, many of the figures are not looking directly at Christ preaching but somewhat lower, revealing that Rembrandt initially intended for Christ to be situated at a lower level.

Similar in subject and setting is *Christ preaching* and again no specific episode of Christ's life can be identified [no.**32**]. This early printed impression on Japanese paper successfully picks up the burr of the drypoint, particularly visible on the completely black sleeve of the man standing it the left foreground [fig.17].

LANDSCAPES

While Rembrandt imbued his religious scenes with dramatic tension, he was a particularly keen observer of his own surroundings, especially the countryside around Amsterdam. *Small Grey Landscape* might have been Rembrandt's first attempt in treating a humble landscape as its own subject [no.**33**]. It is quite different from his later landscape prints in its small size and dense parallel hatching. Nocturnal in atmosphere and lacking in contrasts, it is difficult to make out all the details, such as the small cottage at left with a figure in the lit doorway [fig.18]. Rembrandt continued to make more landscape prints from the 1640s onwards, using larger, wide plates in order to fit his expansive views of the typical flat Dutch terrain with its low horizon. *Cottage beside a Canal with a View of Ouderkerk*, a village just south of Amsterdam, was made around 1641 [no.**34**]. In this delicate view, Rembrandt places the cottage in the left foreground, leading the viewer's eye towards the right, to a wide landscape

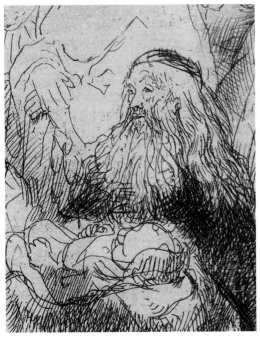

Fig.15 Detail of no.28

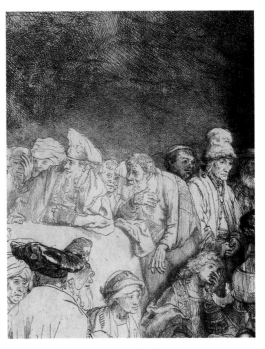

Fig.16 Detail of no.31

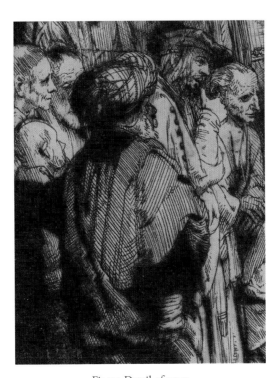

Fig.17 Detail of no.32

with the church spire of Ouderkerk seen faintly in the background. The etched lines appear faintly bitten, while the contours of the cottage and the trees on the left have been strengthened in drypoint, providing the viewer with a focus point. Most of Rembrandt's landscape prints look so naturalistic that it must be questioned whether he made them on the spot, drawn directly onto the copper-plate. One example is the already described *Clump of Trees with a Vista*, in which Rembrandt scratched the drypoint lines in the plate *in situ*, after which he must have worked out the plate in his studio [nos **17** and **18**]. Alternatively, Rembrandt would make drawings of his surroundings in sketchbooks, which he would later transform onto copper-plates. A pen and ink drawing of *Cottages along the Diemerdijk (Saint Anthony's Dike)*, not too far from Rembrandt's house to the east in Amsterdam, shows the same buildings as seen in some of Rembrandt's landscape prints [no.**35**]. While none of the prints reproduce the drawing exactly, it can be assumed that Rembrandt worked from similar drawings in order to recreate some of his views in print, such as *Cottages and a Hay Barn on the Diemerdijk with a Flock of Sheep* [no.**36**].

Panorama near Bloemendaal showing the Saxenburg estate shows another recognisable place [no.**37**]. The high vantage point was taken by Rembrandt sitting on the dunes just outside of Haarlem with the Grote Kerk ('Great Church') seen in the left distance. The other church spire at the centre is that of Bloemendaal, a village at the seafront. As opposed to his other landscape prints, the foreground takes great prominence in this view and the bleaching fields were wrongly thought to belong to Jan Uytenbogaert, hence the print's common title 'The Goldweigher's field' [no.**38**]. This impression is printed on Japanese paper, lending a golden glow to the view.

The Windmill, dated 1641, can almost be interpreted as a portrait of this common landmark [no.**39**]. 'The Little Stink Mill' was situated on the ramparts on the west side of Amsterdam; its name derived from its use by the guild of leather-makers in order to soften leather with pungent cod liver oil. It is symptomatic of Rembrandt's character to feature the least attractive mill in the city. It is also rendered in incredible minutiae, detailing the different working parts of the mill, perhaps not unsurprising as Rembrandt was a miller's son. Hardly noticeable but visible upon closer inspection are the tiny figures in the far distance and the miller walking up the steps to the door of the mill [fig.19].

One of Rembrandt's most admired landscape prints, *The Three Trees*, clearly demonstrates his talent for storytelling, as he rendered a seemingly calm subject as a dramatic stormy scene [no.**10**]. The three trees which dominate the gloomy landscape clearly refer to the three crosses and Christ's crucifixion. Small details not immediately noticeable at first sight slowly grab the viewer's attention: a couple fishing on a river bank at far left, the rabbit in the bushes in the central foreground, the couple of lovers hidden in the foliage at right, the cart on the road behind the trees and the artist sketching on the hill at far right, perhaps Rembrandt himself [fig.20].

GENRE

Besides religious themes and landscapes, Rembrandt's prints feature many genre subjects, everyday scenes which Rembrandt witnessed in the streets of Leiden and

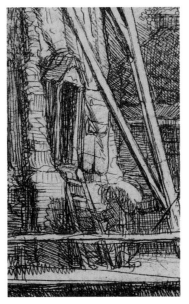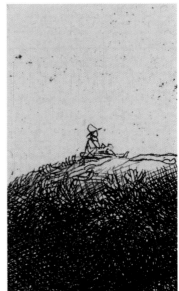

Fig.18 Detail of no.33 Fig.19 Detail of no.39 Fig.20 Detail of no.10

Amsterdam and deemed compelling enough to render into print. In his early career Rembrandt made over 30 etchings of peasants and beggars and their popularity is demonstrated by the many impressions surviving today. While mostly executed between 1629 and 1631, *A Peasant in a high Cap, standing leaning on a Stick* is a relatively late example, made in 1639 [no.**40**]. While Rembrandt was not the first artist to depict street life, the sympathy shown for his subjects is highly original as earlier artists' depictions were mostly mocking or moralising in manner. Rembrandt even depicted himself as a beggar in 1630, as in *Beggar seated on a Bank* [no.**41**].

While he initially singled out individual peasant figures against a neutral background as if they were loosely drawn studies, from 1632 onwards Rembrandt placed these figures within a more narrative context. *The Rat Catcher* is Rembrandt's first effort and the three figures are connected through eye contact and the touching of their hands, even though the bearded man in the doorway seems to be repulsed by the rat catcher and his young assistant [no.**42**]. Signed and dated, it is remarkable that the last two digits of the date appear in reverse, indicating that Rembrandt must have accidentally written them in the correct sense on the copper-plate [fig.8].

The Hog shows a rather unnerving scene once the viewer realises that the pig is tied up to be slaughtered by the butcher who is seen preparing his tools in the background [no.**43**]. For the peasant family, however, this is a joyful occasion as the animal will provide them with meat, and a boy can be seen playing happily with a pig's bladder at the centre. The fattened sow, unaware of its fate, takes prominence by lying in the foreground with its bristly hairs skilfully defined in soft drypoint lines, while Rembrandt has left most of the background blank. A few years earlier, around 1640, Rembrandt made a tender study of a curled dog, *Sleeping Puppy* [no.**44**]. This

seemingly insignificantly tiny plate, measuring just a few centimetres, was surprisingly popular with collectors and dozens of impressions have survived.

In *The Ringball Player (Het Klosbaantje)*, a man is leaning on a table in a tavern, seemingly unaware of being captured by the ever observant Rembrandt [no.**45**]. In the left background, through an open door, another man can be seen playing by pushing the ball with a club, while two others are waiting their turn. By juxtaposing indoors and outdoors, Rembrandt was able to play with light contrasts, densely hatching the right man's shadow while merely outlining the sportsman outside. Done entirely in etching, perhaps even from life, Rembrandt's loose drawing style can be noticed throughout the scene.

NUDES

When it came to nudity, Rembrandt did not follow the classical ideal of showing perfect, streamlined bodies. Instead, he would observe the human body in its natural form and depict it as such. In an episode from the Old Testament, *Joseph and Potiphar's Wife* of 1634, Rembrandt depicts an interior scene with Potiphar's wife trying to seduce Joseph; she is seen naked, almost falling out of bed while trying to grab Joseph by his coat [no.**46**]. In Rembrandt's *Adam and Eve*, the Old Testament couple are represented beyond their prime with sagging bodies [no.**47**]. The figure of Eve appears to be lit from behind, highlighting the shape of her body. The trees in the background, on the other hand, are solely defined by the different direction of the etched lines, with hardly any outlines.

While other artists would also include nudity in biblical and mythological scenes, Rembrandt would controversially also make prints of nude studies of men or women, without any context. In 1646 he made three nude studies in etching, portraying male models from life in his studio. *Nude Man seated in front of a Curtain* features very loose hatching in the background with some engraving to define the young man's face. Rembrandt also used his etching needles to make dots, for instance on the chest, with a dense web of cross-hatching for the curtain behind the model [no.**48**].

Towards the end of his life Rembrandt would focus on female nudes. He created four nude studies in 1658 alone, constituting the majority of his last etchings. The model in *Woman bathing her Feet at a Brook* is shown completely naked, as opposed to Rembrandt's male models who tend to wear a loin cloth [no.**49**]. The woman's pale body and her white cap are contrasted by her dark surroundings. She shows some likeness with the woman depicted in the only known interior view of Rembrandt's workshop in his drawing *The Artist's Studio*, dated in the same year [no.**50**]. A year later, Rembrandt depicts a nude in a mythological print, *Jupiter and Antiope*, an etching which is heavily inspired by Italian examples [no.**51**].

PORTRAITURE

Apart from the different subjects described above, Rembrandt is perhaps best known as a talented portraitist, both of himself as of others. As a young artist, Rembrandt made dozens of self-portraits – in print, drawing and painting – as he was of course his cheapest and most readily available model. Looking at Rembrandt's earliest

self-portraits is like watching over his shoulder in the mirror. These small etchings are mostly studies in facial expression, whether he is smiling, shouting, scowling or pouting. They are all done on postage stamp-sized copper-plates and were probably done directly onto the plate, testimony of their directness. Impressions of *Self-portrait open-mouthed, as if shouting* [no.**52**] and *Self-portrait in a cap, wide-eyed and open-mouthed* [no.**53**], for instance, are both quite rare and were probably not intended to be distributed, but rather to be used as motifs for further use in other works. On the other hand, Rembrandt signed and dated them and some impressions have survived, indicating they must have been sold or given away by the artist. The black edges visible around *Self-portrait open-mouthed* indicate that Rembrandt may have cut down the copper-plate himself without smoothing the edges; these would then catch more ink during printing, resulting in unintended framing lines.

Rembrandt's earliest dated etching, *The Artist's Mother, Head and Bust*, is a delicate, almost vulnerable portrait study made in 1628 when the artist was still living with his parents in Leiden [no.**54**]. As his loving mother, she provided Rembrandt with a patient model while the young artist was practising his printmaking skills. Similarly, there is a stunning drawing of *Rembrandt's Father* in which the old man appears to have fallen asleep, probably tired from posing for his sketching son [no.**55**]. After Rembrandt met his wife Saskia in Amsterdam, he also incorporated her into his prints. The couple married in 1634 and Rembrandt etched a double portrait of them two years later [no.**56**]. They are dressed in historical costume and Saskia is placed more towards the back as if Rembrandt wanted to take centre stage himself. Rembrandt also used Saskia as a model, for instance in *The Great Jewish Bride* of 1635 [no.**16**]. This ambitious plate is almost completely hatched with very few blank areas. It took Rembrandt five states to finish the plate before he was satisfied with the complex hatching of the different textures of the woman's clothes and her long wavy hair. Much later, around 1656, Rembrandt created a touching portrait of their teenage son, *Titus van Rijn* [no.**57**].

As opposed to his early years, Rembrandt made fewer self-portraits in the later 1630s and early 1640s, perhaps because he was too busy painting. *Self-Portrait etching at a Window* from 1648 truly shows the artist at work in his humble working clothes while drawing on a copper-plate, in fact this very print [no.**58**, fourth state]. While he appears to be looking at the viewer with his piercing eyes, in reality the artist would have been looking in the mirror in order to copy his own likeness into the copper. The first state lacks the landscape seen outside the window as well as the signature and date on the curtain in front of the window [no.**59**, first state; fig.21].

While he was mostly active as a portrait painter in Amsterdam from 1631 onwards, Rembrandt would not make portrait prints until 1639. He became particularly focused on these in the 1650s, probably as a source of income undoubtedly linked to his insolvency declared in 1656. All Rembrandt's portrait prints are recognisable by their accurate observation of the sitter's inner character. While most artists would try to make their sitters look as prominent as possible, Rembrandt imbued his portraits with the greatest expression to reflect his sitters' personalities, transforming them into studies of the human face. Interestingly, Rembrandt's portrait prints are all of

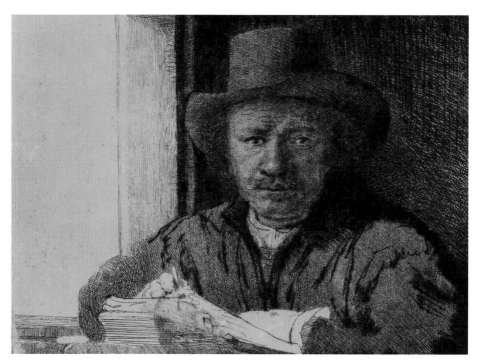

Fig.21 Detail of no.59

men that he knew: either they were family and friends or known through his profession as an artist – collectors, publishers and fellow artists.

Rembrandt's first portrait in print was that of the preacher *Jan Cornelisz. Sylvius* (1564–1638) in 1633, the legal guardian of Rembrandt's wife Saskia, and it can be assumed that this was Rembrandt's first attempt [no.**60**]. It is fairly small and Sylvius appears quite static. After Sylvius' death, Rembrandt would create a second portrait of him in 1646. This work is much more expressive, reflecting his oratorical skills through the expressive hands reaching out beyond the actual image [no.**61**].

Rembrandt's *Portrait of Jan Uytenbogaert, The Goldweigher* (1608–1680), shows the tax collector who acted as an intermediary between Rembrandt and Prince Frederick Henry (1584–1647) while Rembrandt awaited payments from the latter [no.**38**]. It is not unthinkable that Rembrandt made the portrait in recognition for Uytenbogaert's help in this matter, depicting him in sixteenth-century costume and seated at a desk weighing bags of gold coins. The painting hanging on the wall behind him refers to his activities as an art collector. Rembrandt might have met Uytenbogaert in Leiden where he studied Law at the university.

Two years later, in 1641, Rembrandt etched *Portrait of Cornelis Claesz. Anslo* (1592–1646). He was a preacher in Amsterdam who Rembrandt probably knew through his in-laws as they were part of the same Mennonite congregation [no.**62**]. Anslo is shown as a scholar behind a desk piled with large volumes. The inconspicuous nail ('*spijker*' in Dutch) in the wall behind him probably refers to the name of the warehouse where Anslo preached, De Grote Spijker.

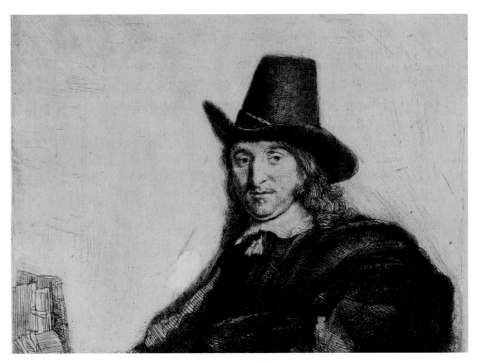

Fig.22 Detail of no.65

Around 1647 Rembrandt portrayed *Jan Asselijn* (*c.*1600–1652), the landscape painter [no.**64**]. While he initially depicted this fellow artist with an easel behind him, he apparently changed his mind – perhaps Rembrandt found it too distracting – and removed it by burnishing the copper-plate [no.**65**; fig.22].

More subtle changes were made on the plate of *Portrait of Clement de Jonghe* (1624/5–1677) created two years later [no.**63**]. Here Rembrandt's friend and print dealer is portrayed informally, relaxing in an arm-chair while his intense gaze rests on the viewer. Rembrandt changed the sitter's expression over the course of five different states, casting it in deeper shadow.

In 1655 – the same year he created the large *Ecce Homo* – Rembrandt was so confident in drypoint that he made two portraits entirely in this technique: *Portrait of Thomas Haaringh* (*c.*1586–1660) and another of his second cousin *Pieter Haaringh* (1609–1685), the so-called Old and Young Haaringh. Both men were Amsterdam auctioneers who were involved in the sale of Rembrandt's possessions before and after his declared insolvency [nos **66** and **67**]. Because of the difficulty of creating delicate portrayals in drypoint and the fragility of the drypoint burr, Rembrandt perhaps wanted to test his own skills in these two works and they rank among his most admired portraits.

In 1658 Rembrandt made a painting and two portrait prints of *Lieven Willemsz. van Coppenol* (1598–*c.*1667), a former headmaster who, after a nervous breakdown, had become fascinated with calligraphy. As he was notoriously vain, Coppenol commissioned self-portraits from a number of artists and often provided them with eulogical

poems about himself. It can be assumed that the smaller plate, in which Coppenol is seen with his grandson standing behind him, was created first and that, not being satisfied with this somewhat plain depiction, he demanded that Rembrandt made a larger and more impressive portrayal [nos **68** and **69**]. His activity as a calligrapher is referred to in the large sheet of paper and quill he is holding. *The Large Coppenol* is printed on Japanese paper, casting the sitter into a warm light (see p.10).

This selective overview of Rembrandt's prints reveals him to be an innovative and experimental printmaker (see pp. 8–11), who used his skills in observation to create the most fascinating works of art in print. Rembrandt seems to never have shared his printmaking activities with his pupils and assistants, considering them personal endeavours. It is thus a great privilege for viewers today to be able to admire Rembrandt's prints in such detail.

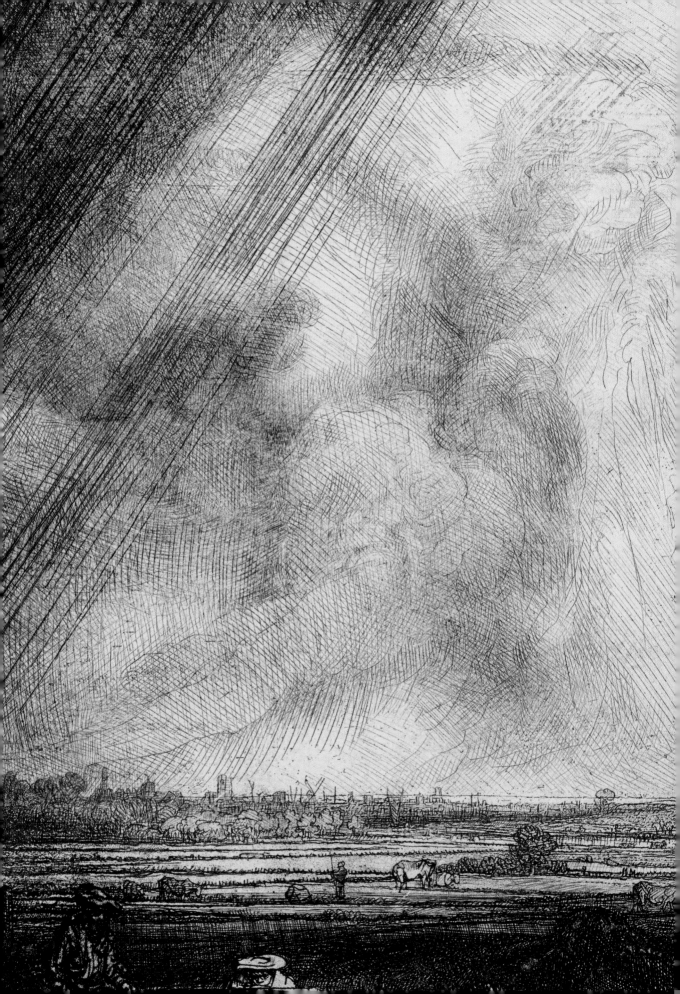

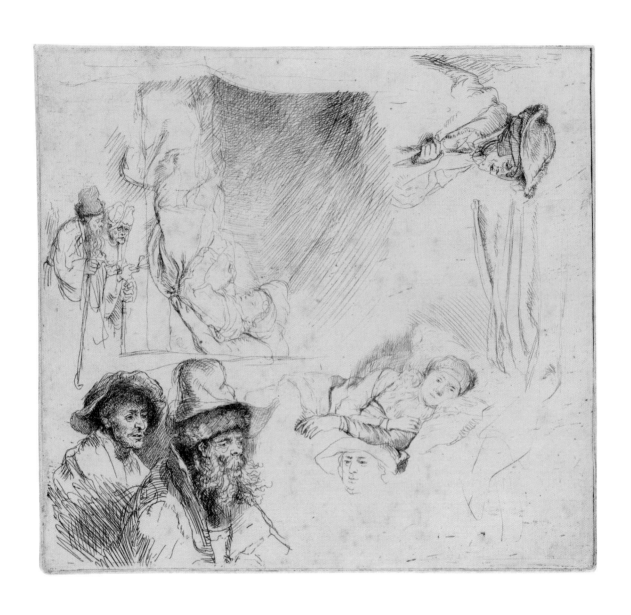

1

Sheet of Studies, with a Woman lying ill in Bed, *c*.1639
Etching on laid paper, 13.8 × 15.1 cm
WA1855.385

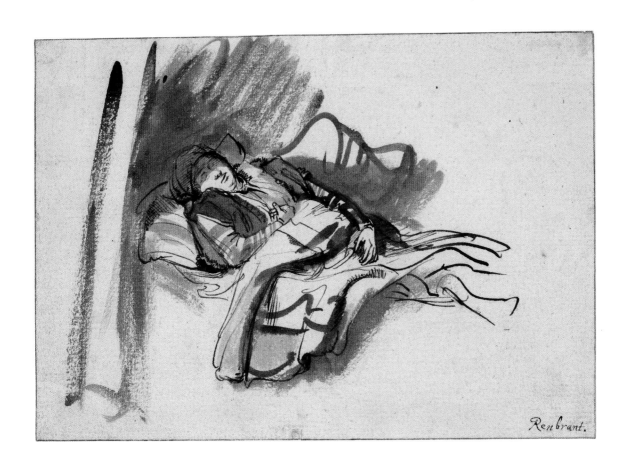

2
Saskia asleep in Bed, 1640–42
Pen and brush in brown ink with brown wash on laid paper, 14.4 × 20.8 cm
WA1954.141

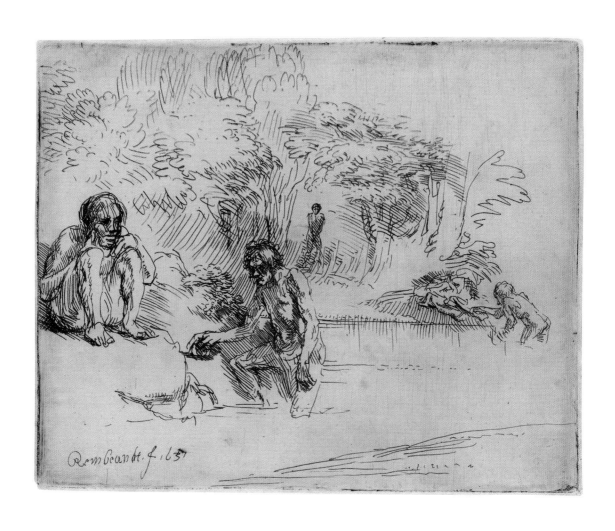

3
The Bathers (*'De Zwemmertjes'*), 1651
Etching on laid paper, 10.9 × 13.8 cm
WA1855.358

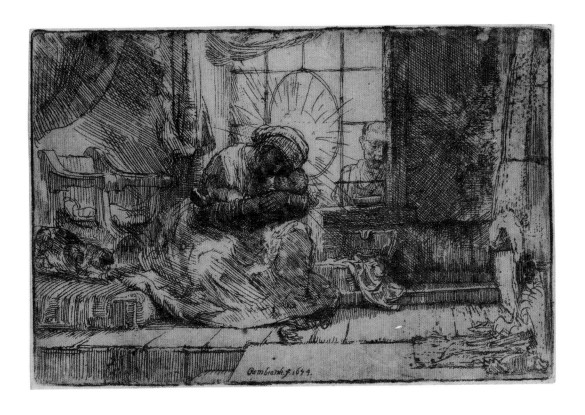

4
The Virgin and Child with the Cat and Snake, 1654
Etching with plate tone on laid paper, 9.5 × 14.5
WA1855.341

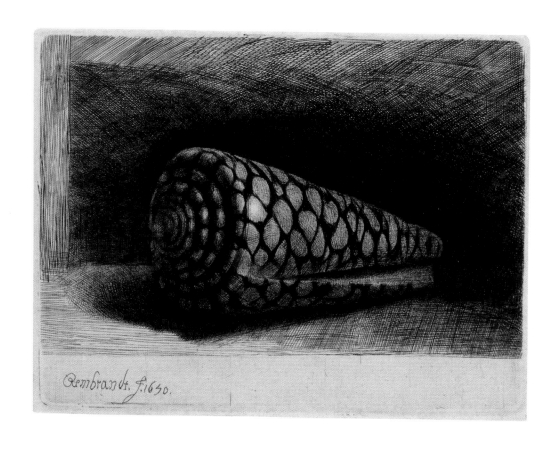

5
The Shell, 1650
Etching, engraving and drypoint on laid paper, 9.9 × 13.2 cm
WA1855.308

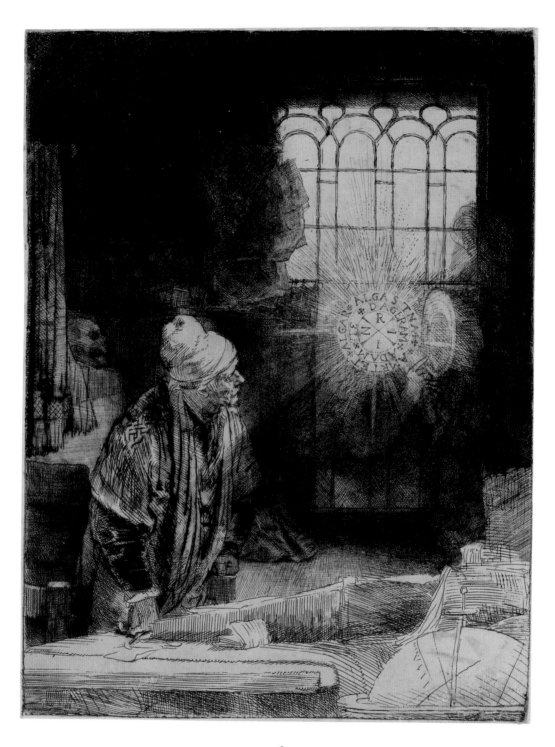

6

A Scholar in his Study (*Faust*), c.1652
Etching, engraving and drypoint on laid paper, 20.8 × 16 cm
WA1855.411

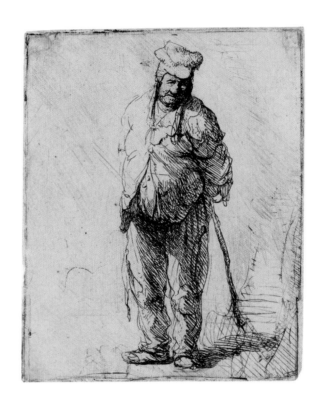

7
Ragged Peasant with his Hands behind Him, holding a Stick, c.1630
Etching on laid paper, 9.2 × 7.5 cm
WA1855.408

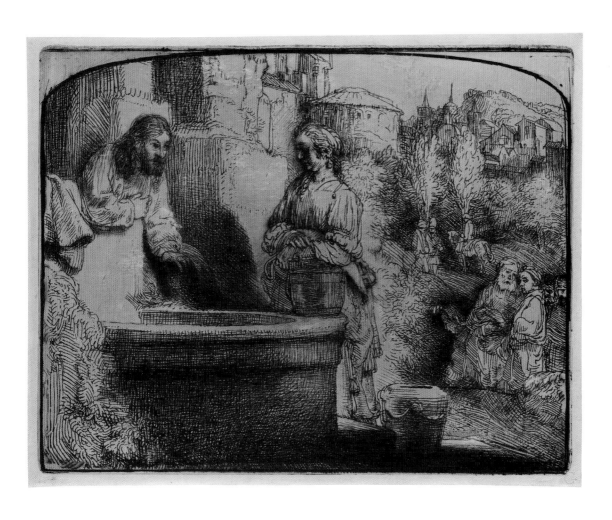

8
Christ and the Woman of Samaria: an arched print, c.1657
Etching and drypoint with plate tone on Japanese paper, 12.5 × 16 cm
WA1855.323

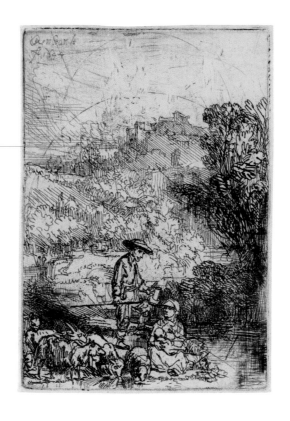

9
The Shepherd and his Family ('*Het Hardertje*'), 1644
Etching on laid paper, 9.5 × 6.7 cm
WA1855.273.1

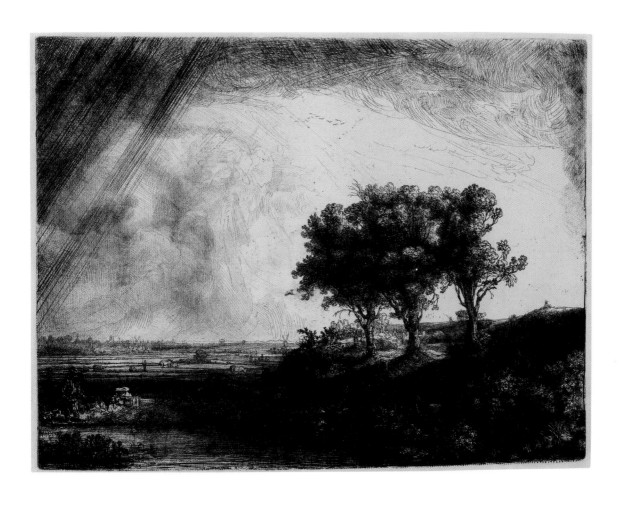

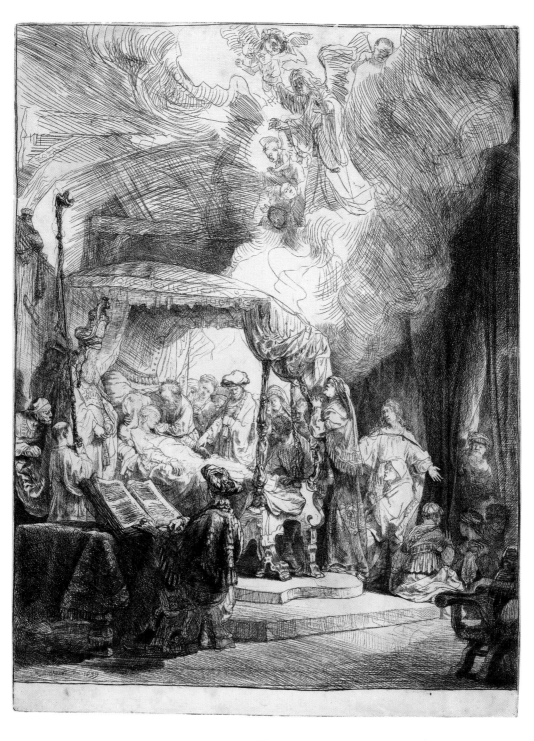

II

The Death of the Virgin, 1639
Etching and drypoint on laid paper, 40.7 × 31 cm
WAI855.421

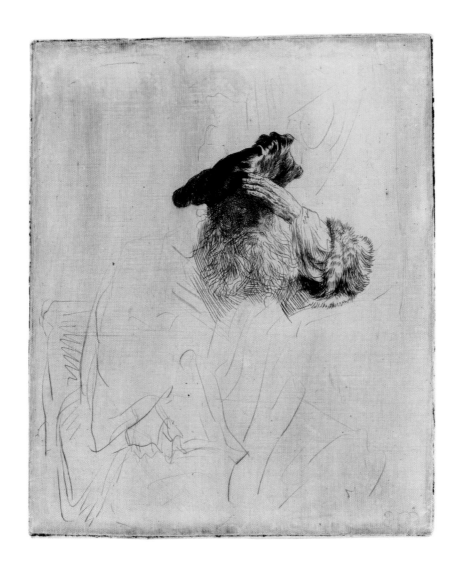

12
*Old Man shading his Eyes with his Hand, c.*1639
Etching and drypoint on laid paper, 13.2 × 11.3 cm
WA1855.285

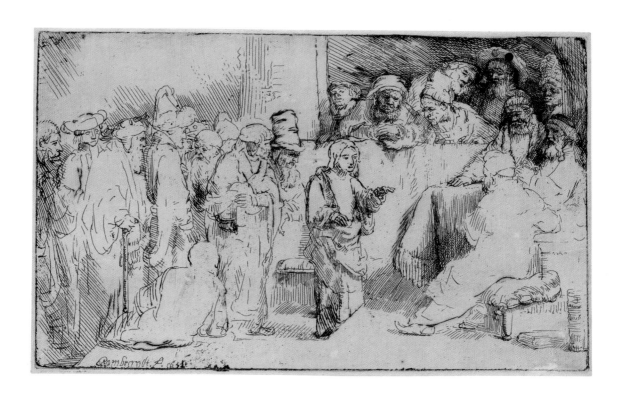

13
Christ disputing with the Doctors: a sketch, 1652
Etching and drypoint on laid paper, 12.6 × 21.4 cm
WA1855.362

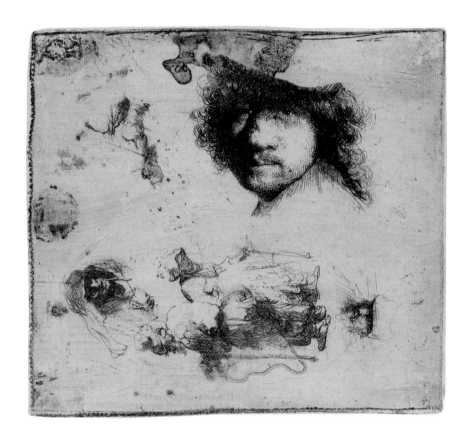

14
Sheet of studies: Head of the Artist, A beggar Couple,
Heads of an old Man and old Woman, etc, 1632
Etching on laid paper, 10.1 × 11.4 cm
WA1855.387

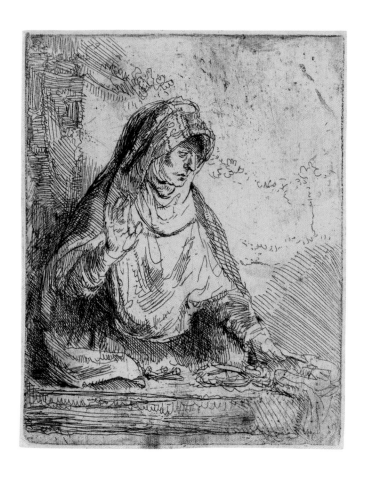

15
*The Virgin with the Instruments of the Passion, c.*1642
Etching and drypoint on laid paper, 11 × 8.8 cm
WA1855.337

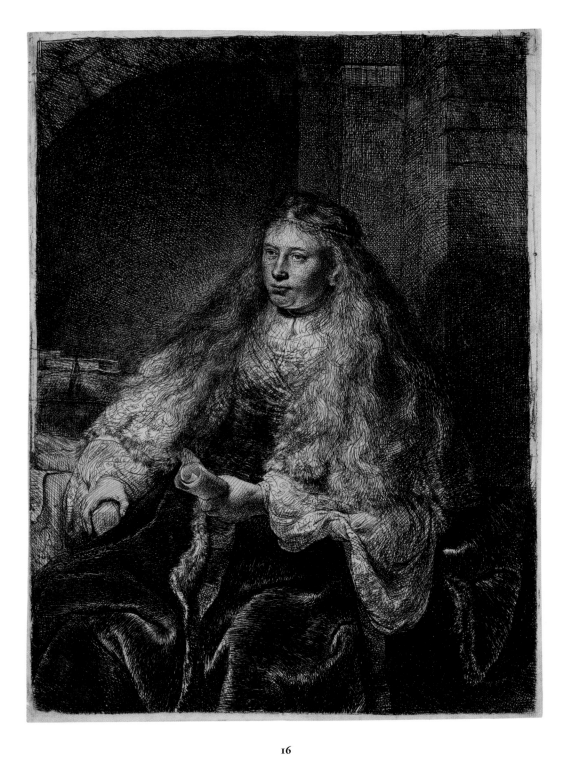

16
The Great Jewish Bride, 1635
Etching, some drypoint and engraving on laid paper, 21.8 × 17 cm
WA1855.277

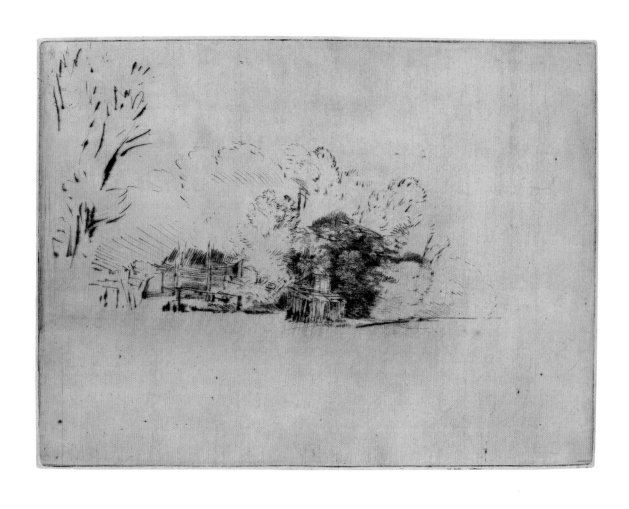

17
Clump of Trees with a Vista, 1652
Drypoint on laid paper (first state), 15.7 × 21.2 cm
WA1855.425

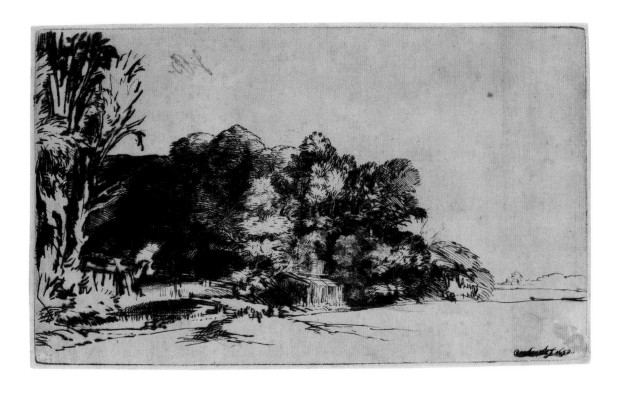

18
Clump of Trees with a Vista, 1652
Drypoint on laid paper (second state), 12.3 × 21.1 cm
WA1855.424

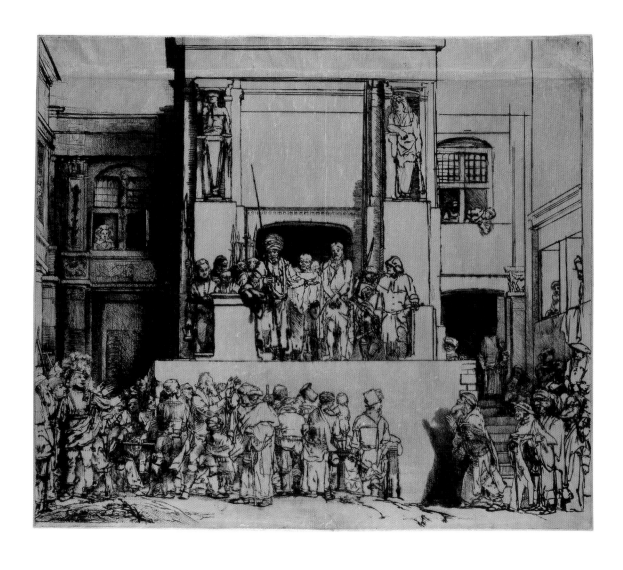

19
Christ presented to the People, 1655
Drypoint on Japanese paper, 38.3 × 45.5 cm
WA1855.442

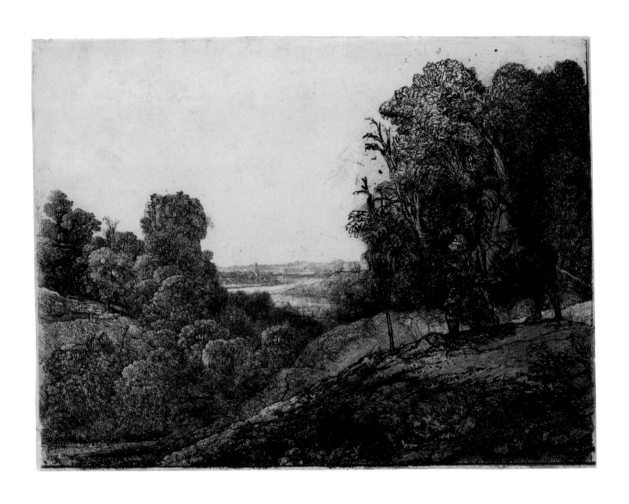

20

The Flight into Egypt: altered from Segers, c.1652
Etching, engraving and drypoint with plate tone on laid paper, 20.9 × 28.3 cm
WA1855.328

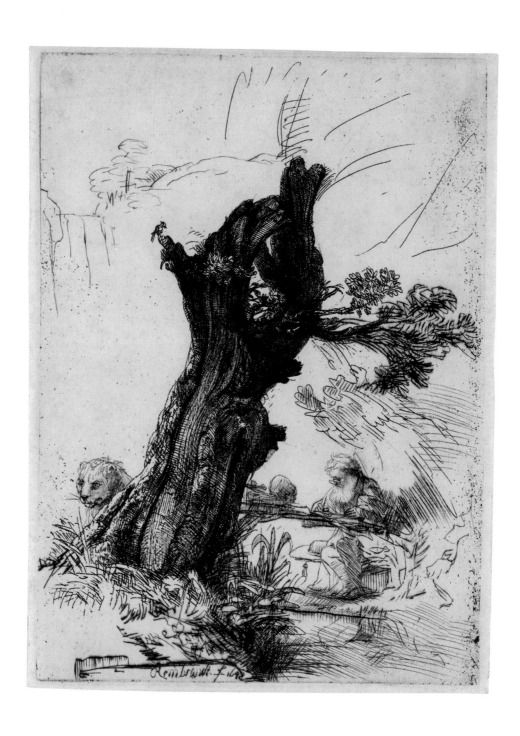

21
Saint Jerome beside a pollard Willow, 1648
Etching and drypoint on laid paper, 18 × 13.3 cm
WA1855.431

48

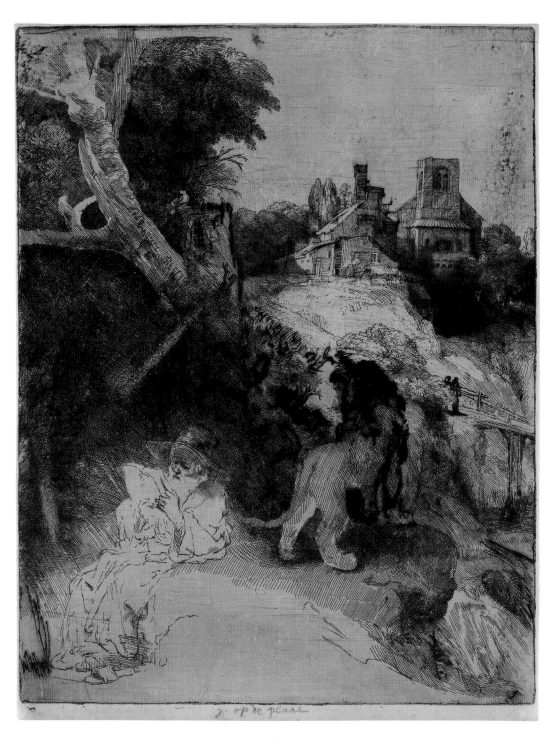

22

Saint Jerome Reading in an Italian Landscape, c.1653
Etching and drypoint on Japanese paper, 25.8 × 20.5 cm
WA1855.329

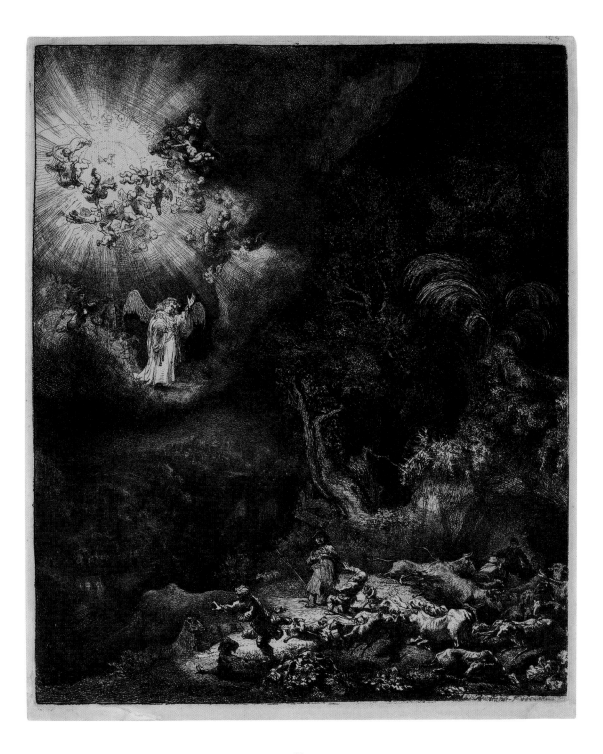

23
The Angel appearing to the Shepherds, 1634
Etching, engraving and drypoint on laid paper, 26.1 × 21.7 cm
WA1855.423

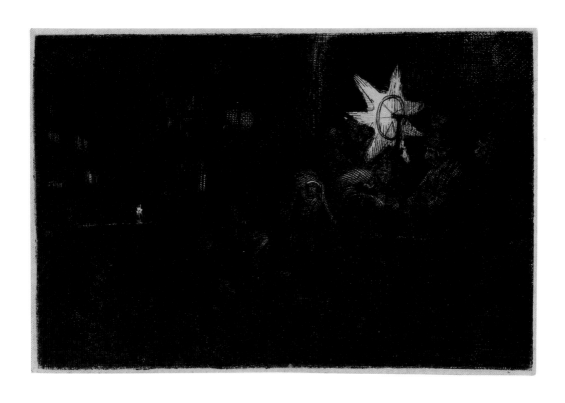

24
*The Star of the Kings: a night piece, c.*1651
Etching with touches of drypoint on laid paper, 9.4 × 14.3 cm
WA1855.346

51

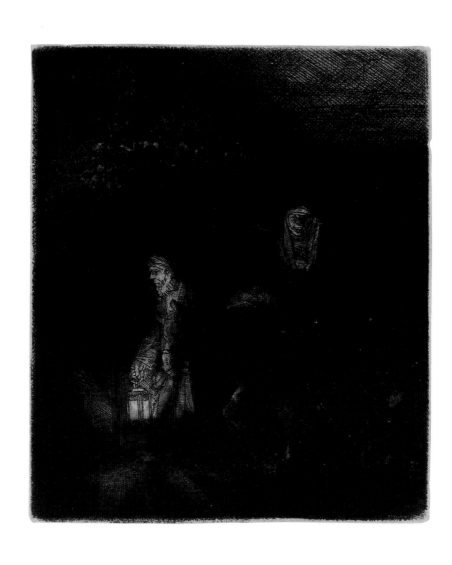

25
The Flight into Egypt: a night piece, 1651
Etching and drypoint on laid paper, 12.7 × 11 cm
WA1855.325

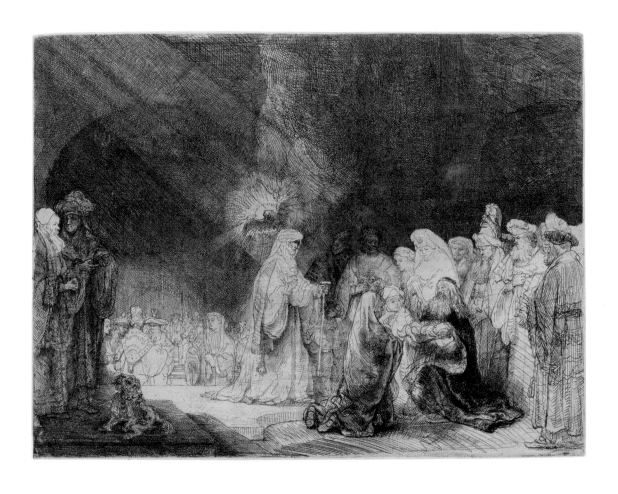

28
*The Presentation in the Temple: oblong print, c.*1639
Etching and drypoint on laid paper (second state), 21.3 × 28.8 cm
WA1855.318

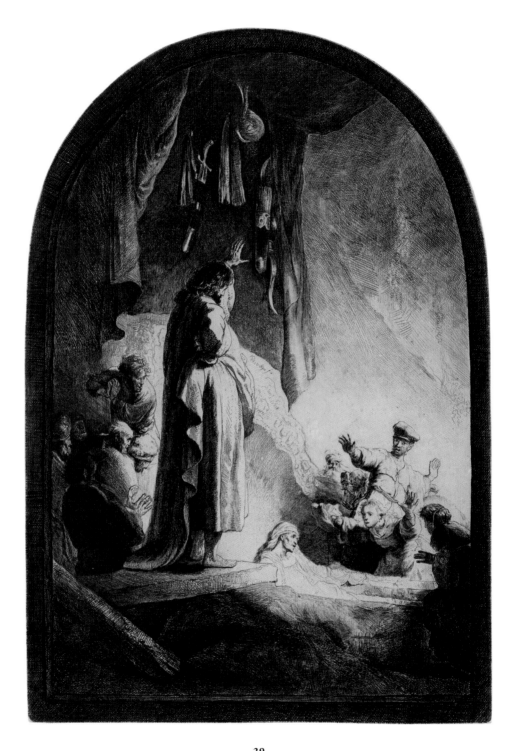

29
The Raising of Lazarus: the larger plate, 1632
Etching and engraving on laid paper, 36.6 × 25.8 cm
WA1855.324

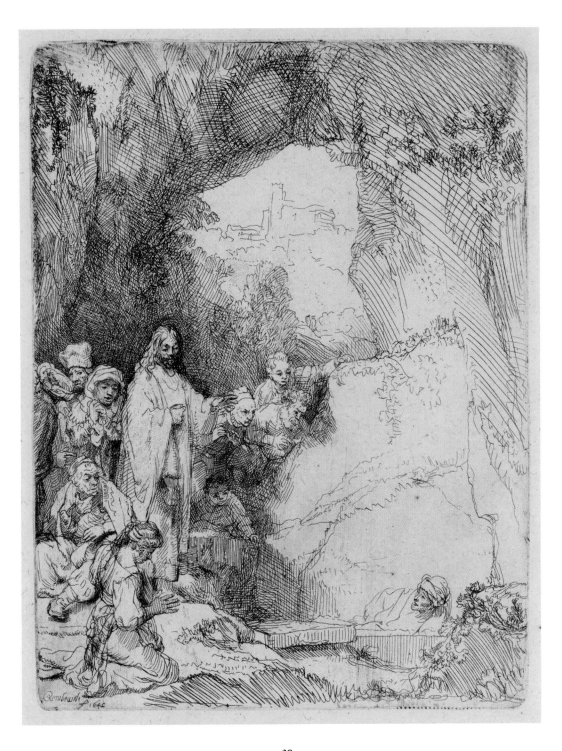

30
The Raising of Lazarus: small plate, 1642
Etching on laid paper, 15 × 11.4 cm
WA1855.396

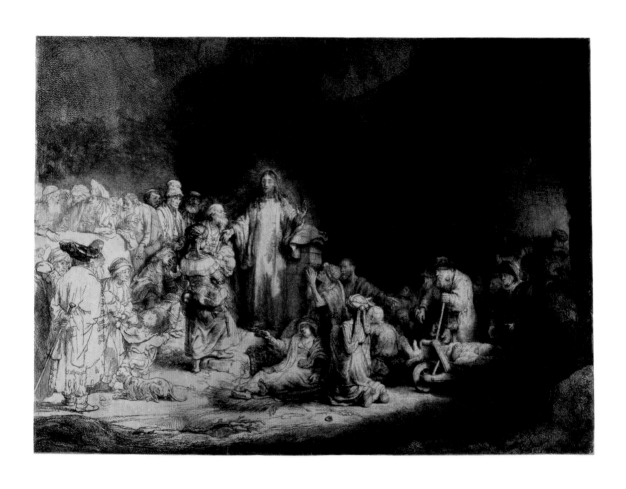

31
*The Hundred Guilder Print, c.*1648
Etching, drypoint and engraving on Japanese paper, 27.8 × 38.4 cm
WA1946.225

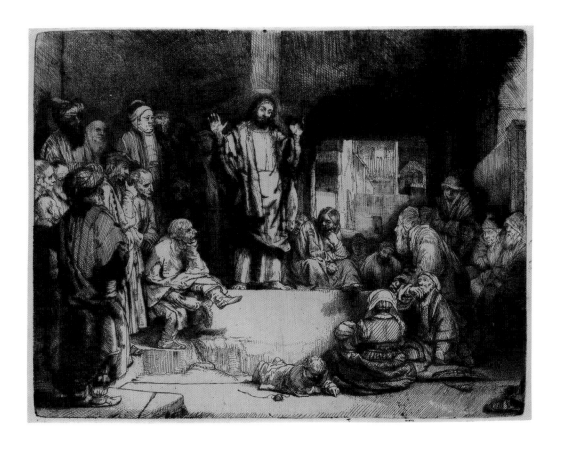

32
*Christ preaching, c.*1657
Etching and drypoint on Japanese paper, 15.5 × 20.3 cm
WA1855.412

59

33
*Small grey Landscape: a House and Trees beside a Pool, c.*1640
Etching on laid paper, 3.8 × 8.2 cm
WA1855.272

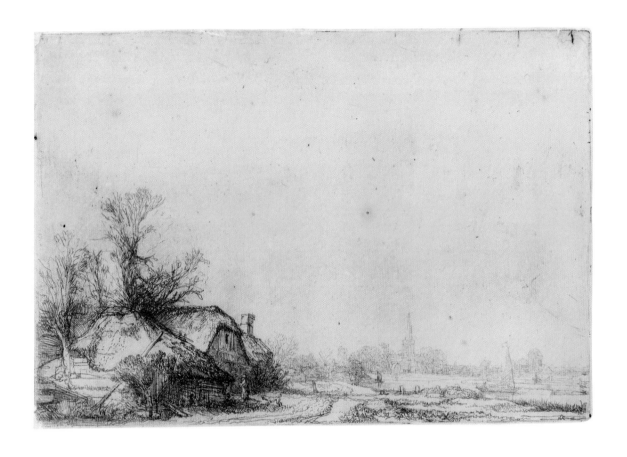

34
*Cottage beside a Canal with a View of Ouderkerk, c.*1641
Etching and drypoint on laid paper, 14.1 × 20.6 cm
WA1855.274

61

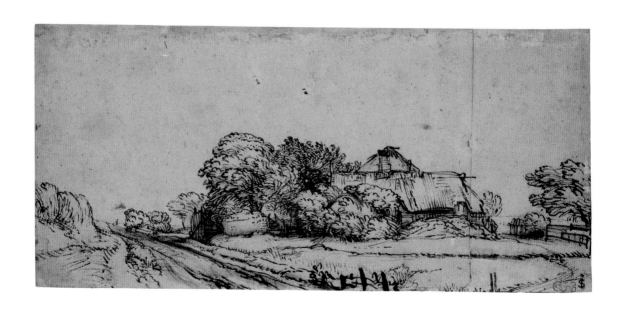

35
Farm Buildings beside a Road, 1650–69
Pen and brown ink with brown wash on laid paper, 11.3 × 24.8 cm
WA1855.22

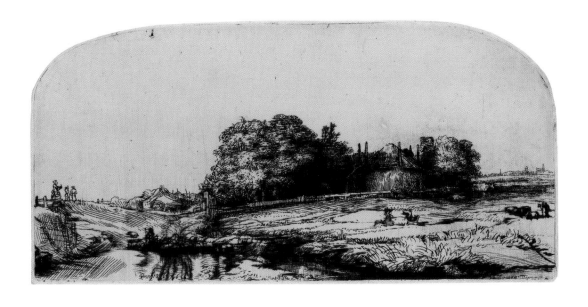

36
Cottages and a Hay Barn on the Diemerdijk with a Flock of Sheep, 1652
Etching and drypoint on laid paper, 8.2 × 17.4 cm
WA1855.376

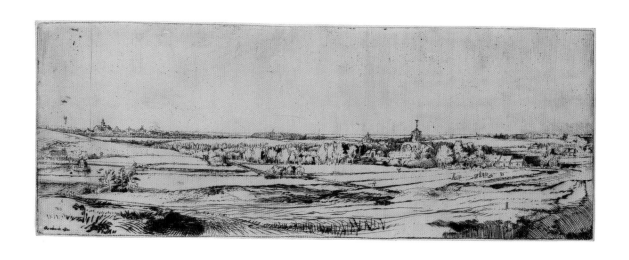

37
Panorama near Bloemendaal showing the Saxenburg estate ('The Goldweigher's field'), 1651
Etching and drypoint on Japanese paper, 11.7 × 31.8 cm
WA1855.264

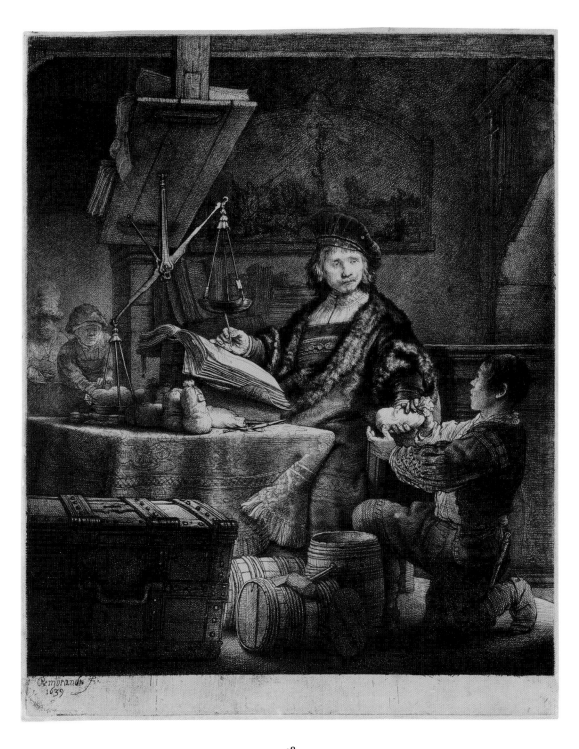

38
Portrait of Jan Uytenbogaert, 'The Goldweigher', 1639
Etching and drypoint on laid paper, 25.3 × 20.3 cm
WA1855.422

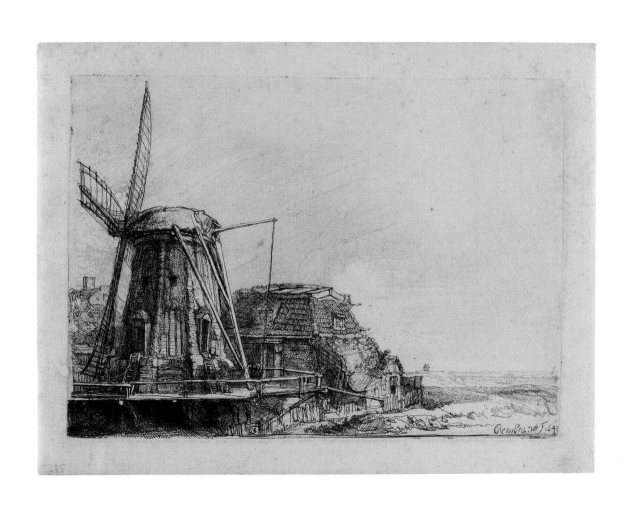

39
The Windmill, 1641
Etching on laid paper, 14.5 × 20.5 cm
WA1855.380

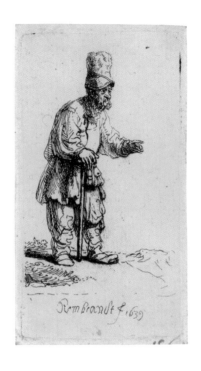

40

A *Peasant in a high Cap, standing leaning on a Stick*, 1639
Etching on laid paper, 8.3 × 4.5 cm
WA1855.315

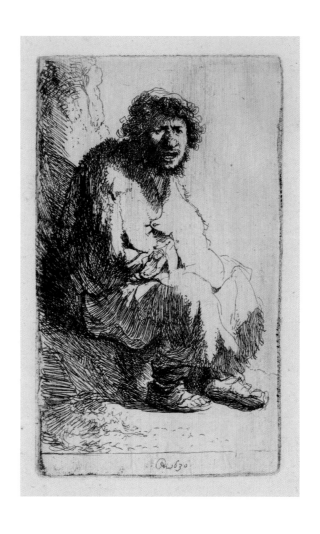

41
Beggar seated on a Bank, 1630
Etching on laid paper, 11.7 × 7 cm
WA1855.299

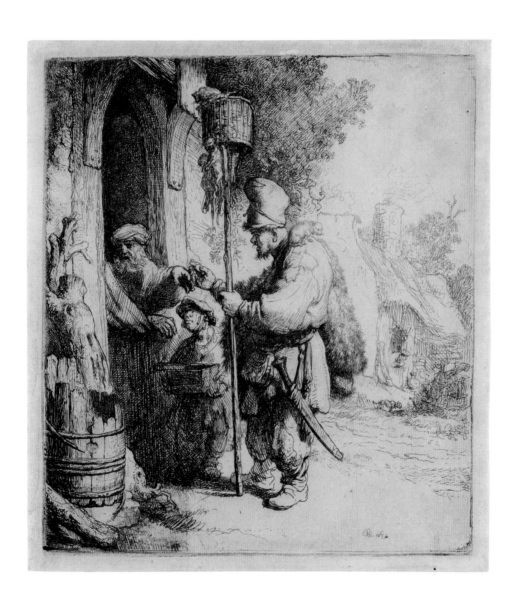

42
The Rat Catcher, 1632
Etching on laid paper, 13.9 × 12.8 cm
WA1855.344

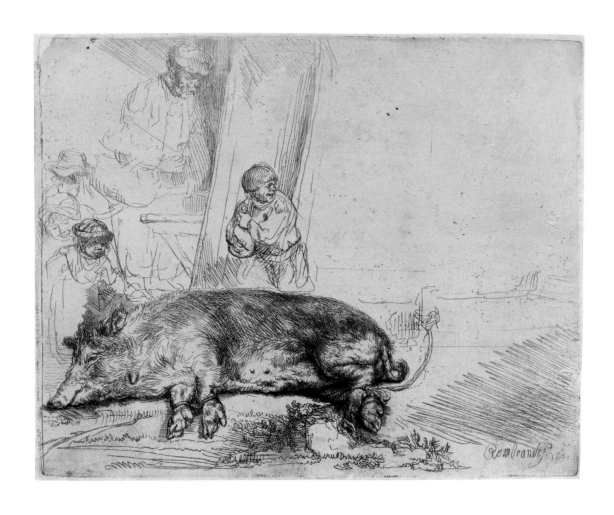

43
The Hog, 1643
Etching and drypoint on laid paper, 14.3 × 18.1 cm
WA1855.339

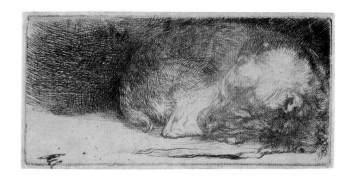

44
Sleeping Puppy, c.1640
Etching and drypoint on laid paper, 3.8 × 8.1 cm
WA1855.316

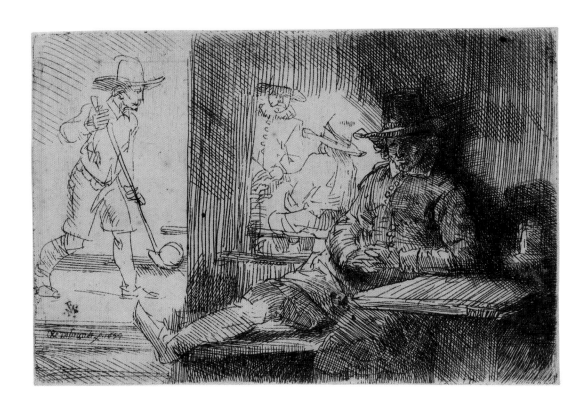

45
The Ringball Player (*'Het Klosbaantje'*), 1654
Etching on laid paper, 9.5 × 14.3 cm
WA1855.384

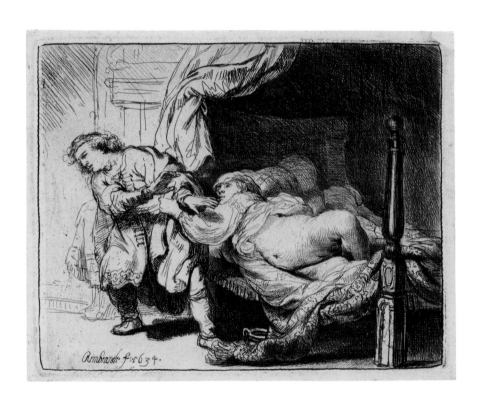

46
Joseph and Potiphar's Wife, 1634
Etching on laid paper, 9 × 11.5 cm
WA1863.1859

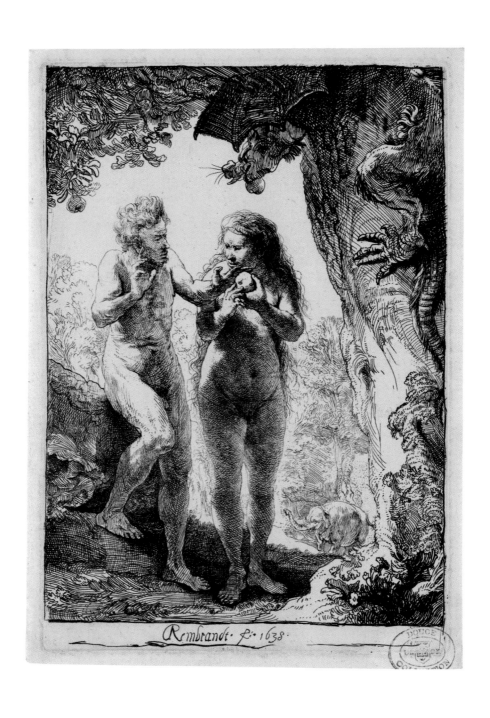

47
Adam and Eve, 1638
Etching and drypoint on laid paper, 16.4 × 11.6 cm
WA1863.1857

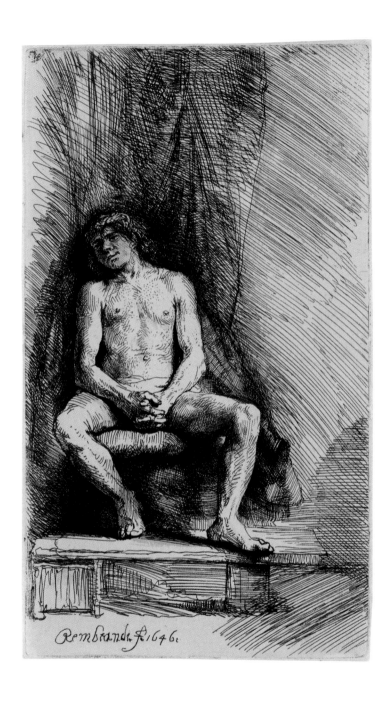

48
Nude Man seated before a Curtain, 1646
Etching on laid paper, 16.4 × 9.6 cm
WA1855.366

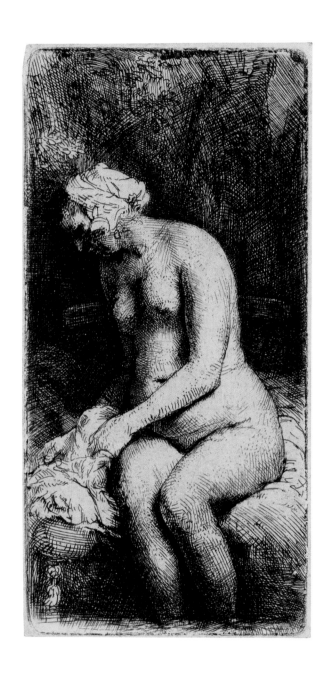

49
Woman bathing her Feet at a Brook, 1658
Etching on laid paper, 15.9 × 8 cm
WA1855.355

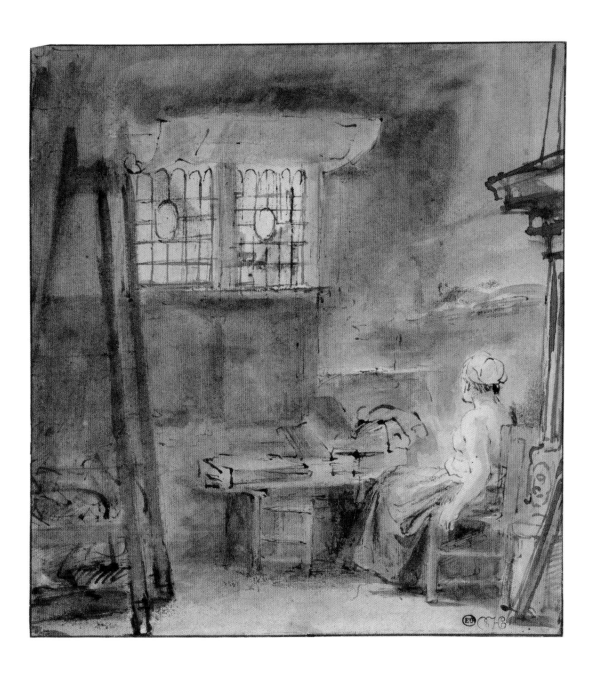

50
The Artist's Studio
Pen and brown ink with grey-brown wash and white bodycolour on laid paper, 20.5 × 18.9 cm
WA1855.8

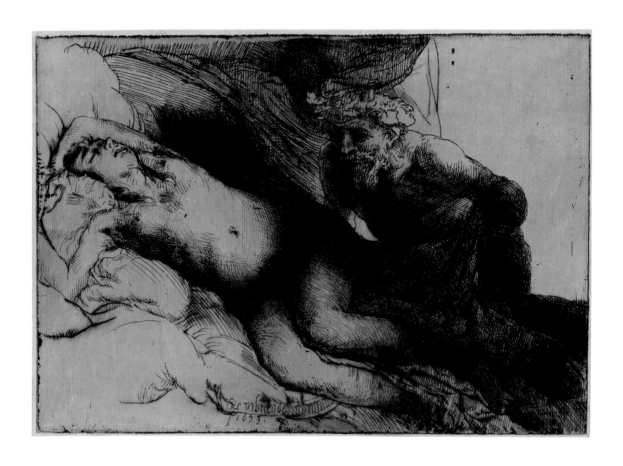

51
Jupiter and Antiope: the larger plate, 1659
Etching and drypoint on laid paper, 13.8 × 19.9 cm
WA1855.382

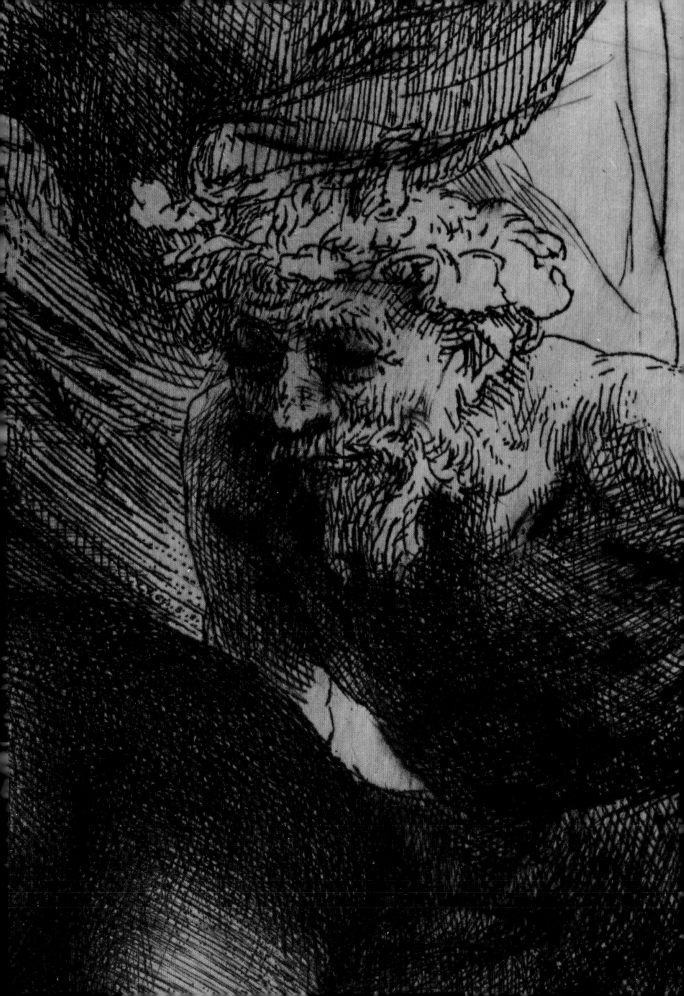

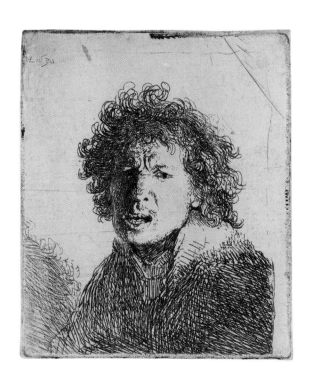

52
Self-portrait open-mouthed, as if shouting: bust, 1630
Etching on laid paper, 7.2 × 6.2 cm
WA1855.320

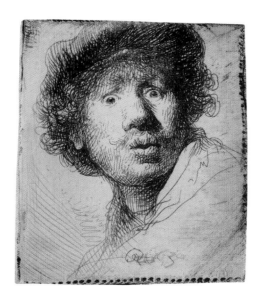

53
Self-portrait in a cap, open-mouthed, 1630
Etching and drypoint on laid paper, 5.2 × 4.7 cm
WA1855.368

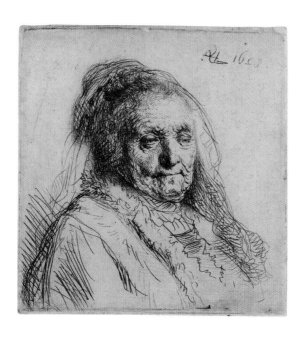

54
The Artist's Mother, Head and Bust: three quarters right, 1628
Etching on laid paper, 6.6 × 6.5 cm
WA1855.394

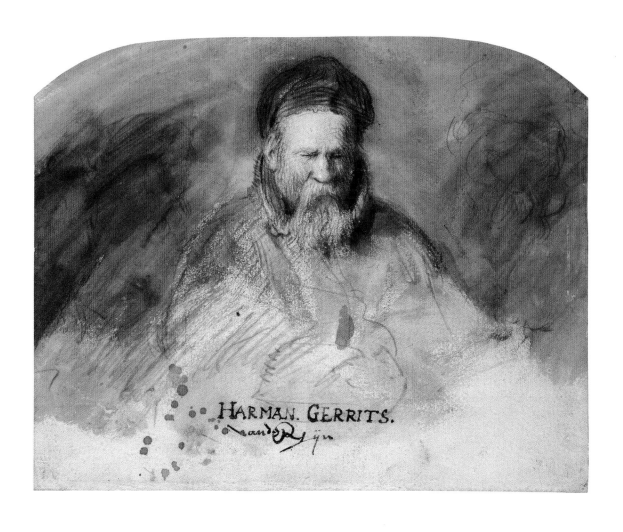

55
Portrait of an Old Man (*Rembrandt's father*), 1627–30
Red and black chalk with brown wash on laid paper (arched), 18.9 × 24 cm
WA1855.11

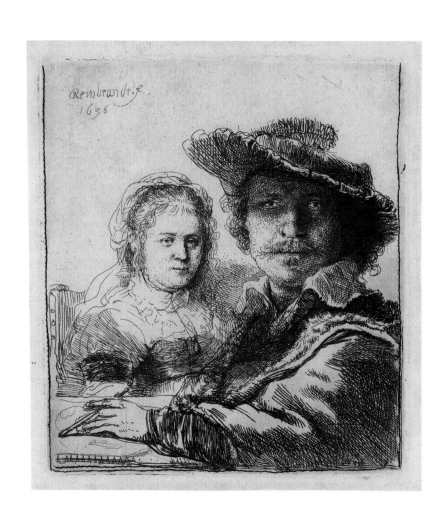

56
Self-portrait with Saskia, 1636
Etching on laid paper, 10.4 × 9.2 cm
WA1855.437

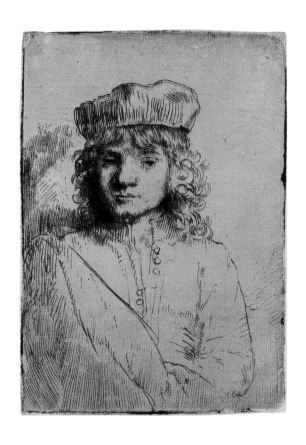

57
*The Artist's Son, Titus, c.*1656
Etching on laid paper, 9.8 × 7 cm
WA1855.278

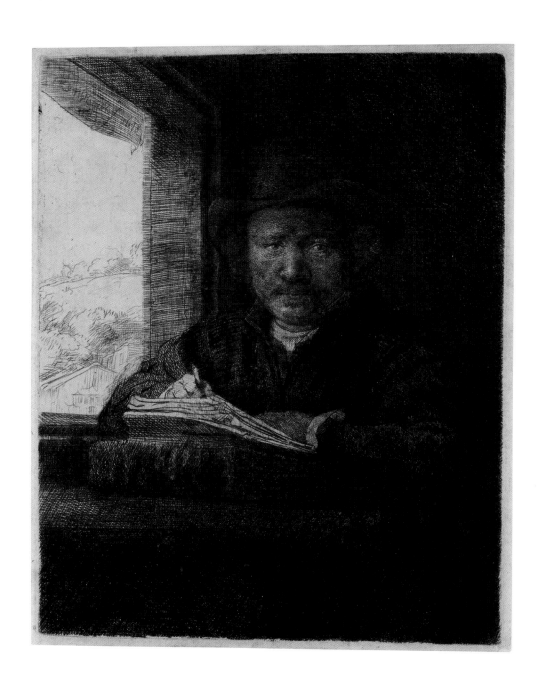

58
Self-portrait etching at a Window, 1648
Etching and drypoint with some engraving on laid paper (fourth state), 15.5 × 12.8 cm
WA1855.292

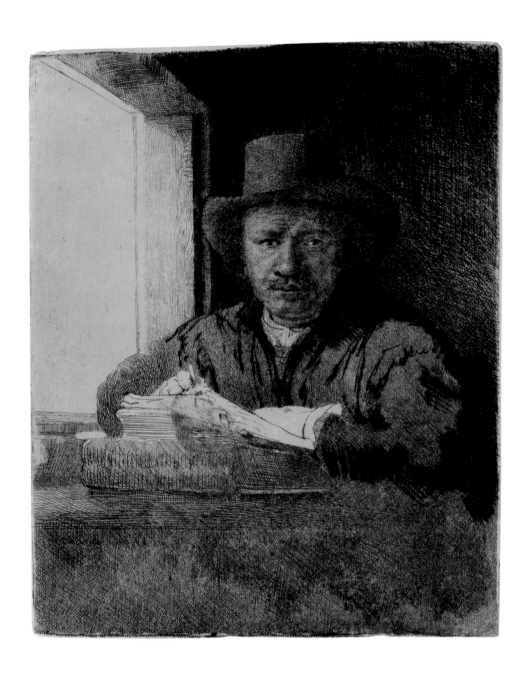

59
Self-portrait etching at a Window, 1648
Etching and drypoint with some engraving on laid paper (first state), 15.4 × 12.8 cm
WA1855.294

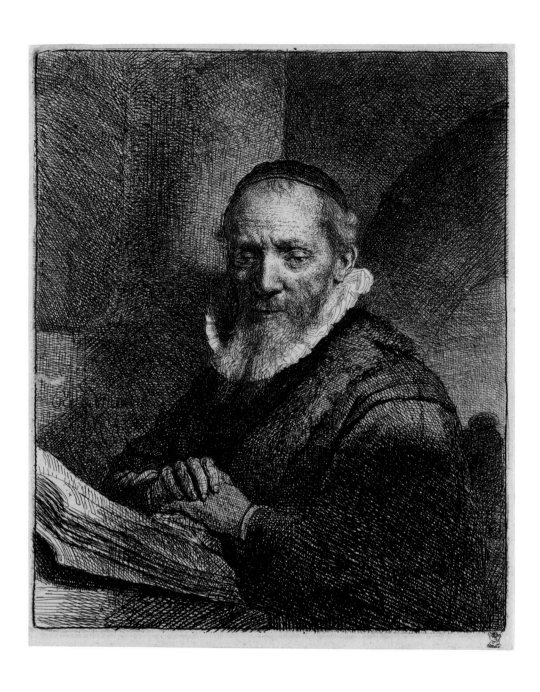

60
Portrait of Jan Cornelisz. Sylvius, Preacher, 1633
Etching on laid paper, 16.7 × 14 cm
WA1855.364

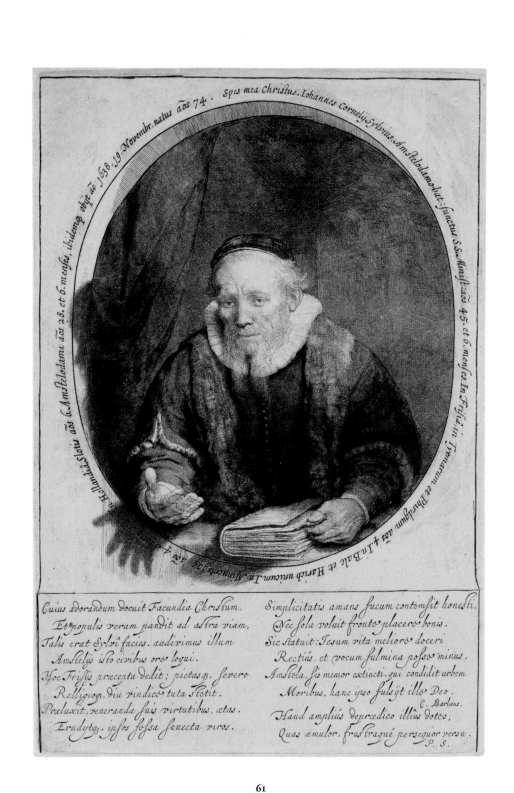

61
Portrait of Jan Cornelisz. Sylvius, Preacher, 1646
Etching, engraving and drypoint on laid paper, 27.6 × 18.7 cm
WA1855.433

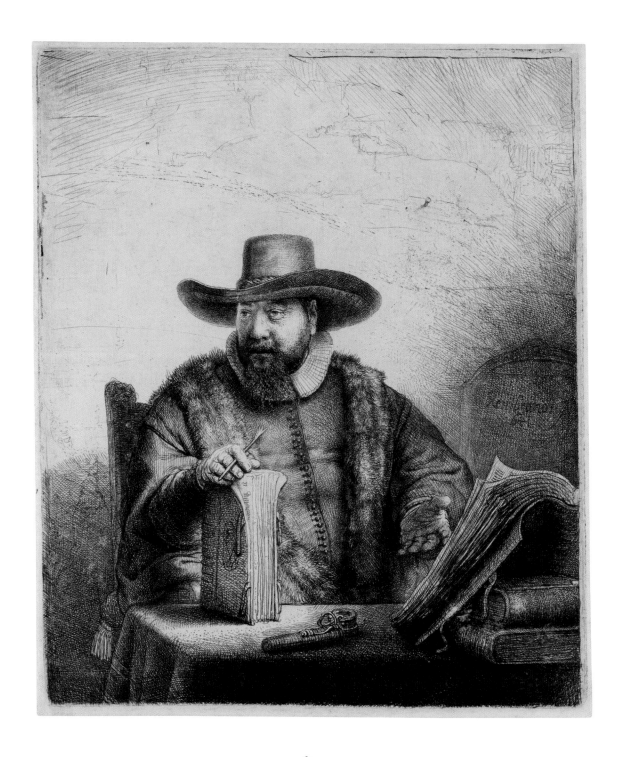

62
Portrait of Cornelis Claesz. Anslo, Preacher, 1641
Etching and drypoint on laid paper, 18.5 × 15.9 cm
WA1855.381

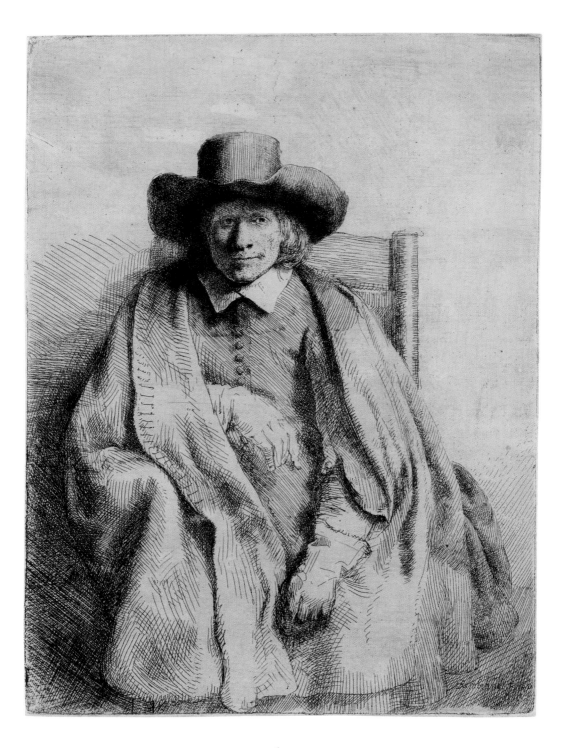

63
Clement de Jonghe, Printseller, 1651
Etching and drypoint on laid paper, 20.8 × 16.2 cm
WA1855.401

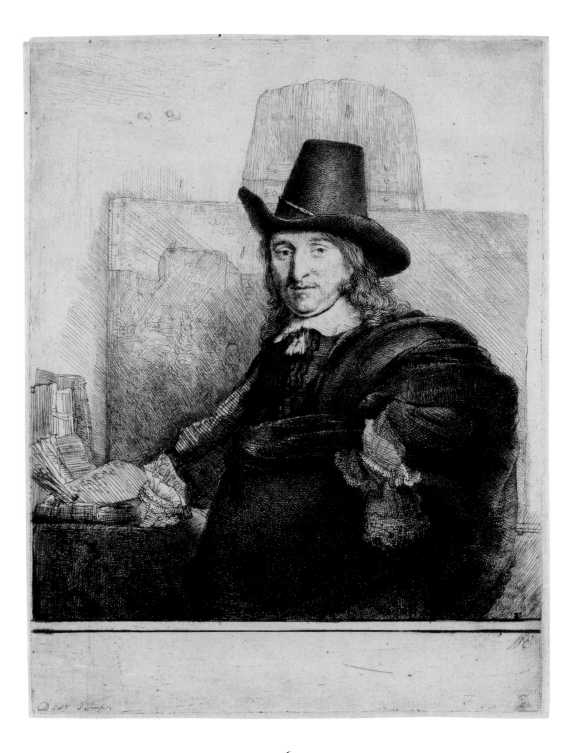

64
Jan Asselijn, Painter, c.1647
Etching, engraving and drypoint on laid paper (first state), 21.5 × 17.2 cm
WA1855.280

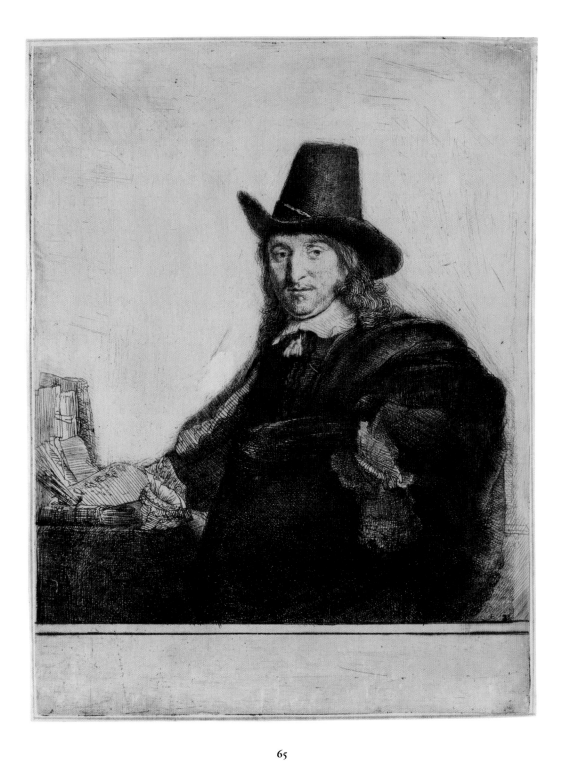

65
*Jan Asselijn, Painter, c.*1647
Etching, engraving and drypoint on Japanese paper (second state), 21.7 × 16.6 cm
WA1855.279

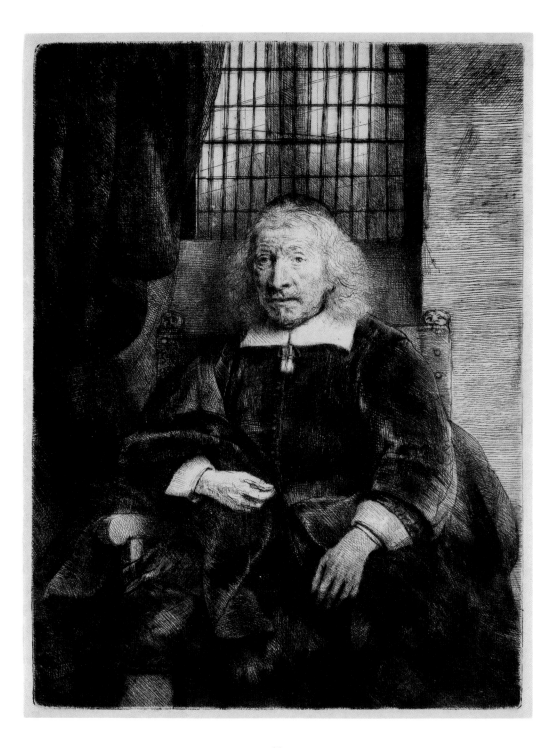

66
Thomas Haaringh (*'Old Haaringh'*), *c.*1655
Drypoint with some engraving on laid paper, 19.6 × 15 cm
WA1855.288

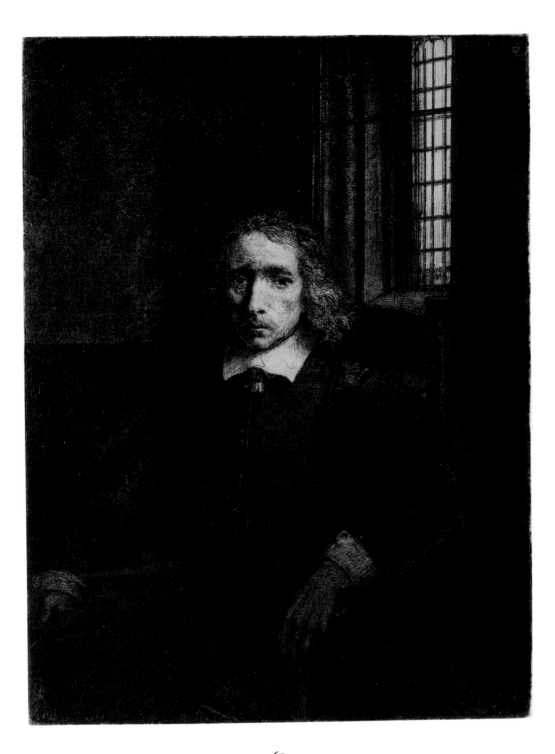

67
Pieter Haaringh (*'Young Haaringh'*), 1655
Etching and drypoint on laid paper, 19.4 × 14.8 cm (trimmed)
WA1855.287

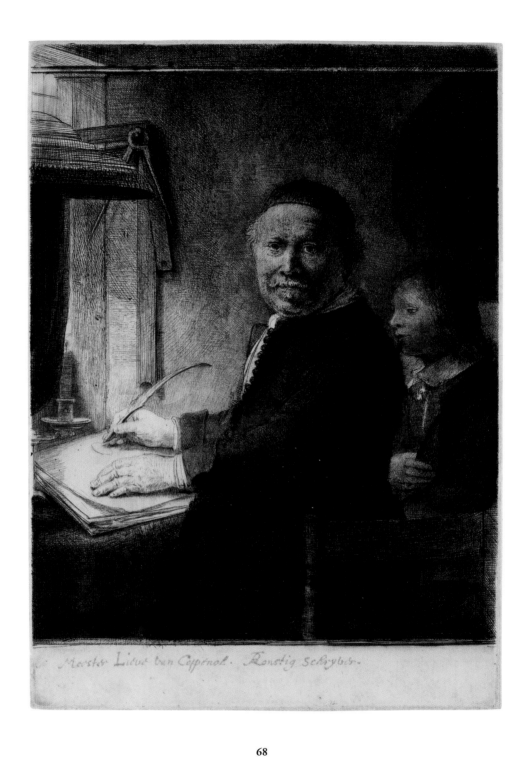

68
Lieven Willemsz. van Coppenol, Writing-Master: the smaller plate, c.1658
Etching, engraving and drypoint on laid paper, 26.2 × 19.1 cm
WA1855.289

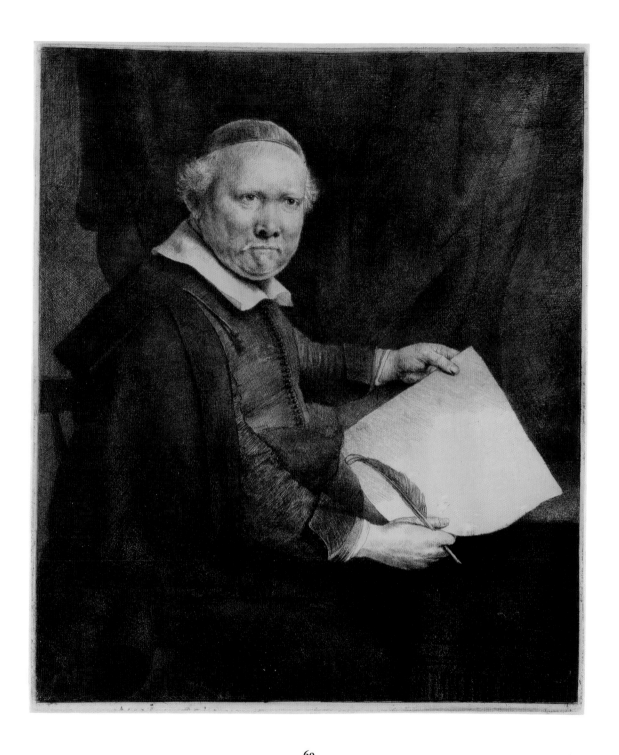

69
Lieven Willemsz. van Coppenol, Writing-Master: the larger plate, 1658
Etching, engraving and drypoint on Japanese paper, 33.5 × 28.7 cm
WA1855.434

REMBRANDT PRINTS IN OXFORD

WORKS ON PAPER IN THE ASHMOLEAN

The Ashmolean Museum boasts a world-class collection of works on paper by Rembrandt van Rijn (1606–1669), counting over 200 prints and more than twenty drawings. When the Ashmolean – the oldest public museum in Britain and the world's first university museum – was founded in 1683, prints and drawings were not a prominent part of its collection. Started in the early seventeenth century by two gardeners, John Tradescant the Elder (*c*.1570s–1638) and the Younger (1608–1662), and subsequently expanded by Elias Ashmole (1617–1692), the founding collection consisted mainly of botanical, natural history and ethnographical objects, antique coins, medals and books. It was Ashmole who donated the entire collection to the University of Oxford, thus giving his name to the museum.

Apart from some printed books, manuscripts and painted portraits of the Tradescants and Ashmole, the founding collection was, as noted, not particularly strong on art. This changed in the early nineteenth century when in 1842, through public subscription, the University acquired an important group of drawings by Raphael and Michelangelo from the celebrated collection of the portrait painter Sir Thomas Lawrence (1769–1830). This high-profile acquisition laid the foundation of the museum's collection of works on paper and was soon afterwards supplemented by an extraordinary gift from the art collector Chambers Hall (1786–1855), shortly before his death in 1855. An amateur watercolourist himself, Chambers Hall was born into a naval family from Southampton and became one of the foremost British collectors of his time. In addition to an important group of oil sketches by the Flemish artist Peter Paul Rubens (1577–1640), the donation included superb prints and drawings by other Northern European artists such as Anthony van Dyck (1599–1641) and Adriaen van Ostade (1610–1685), as well as a handful of sheets by Leonardo da Vinci (1452–1519) among others.

Of particular note were almost two hundred prints and a few dozen drawings by Rembrandt, forming the core of the Ashmolean's collection of works by the artist. Chambers Hall had an excellent eye for quality, only acquiring the best works and his Rembrandt prints are among the finest sheets by the artist. Particularly spectacular is a rare impression of the first state of *Christ presented to the People*, which ranks as one of Rembrandt's masterpieces entirely executed in drypoint [no.**19**]. Equally, an impression of *Saint Jerome reading in an Italian landscape* is extraordinarily inscribed by Rembrandt himself '7. op de plaat', revealing it was the seventh impression ever taken from the copper-plate [no.**20**].

Following the Chambers Hall gift, the Ashmolean acquired further prints and drawings by Rembrandt, notably from the collection of Francis Douce (1757–1834) who bequeathed his collection to the University of Oxford in 1834. This was an eclectic collection of tens of thousands of prints and drawings, including a handful

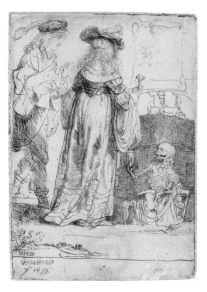

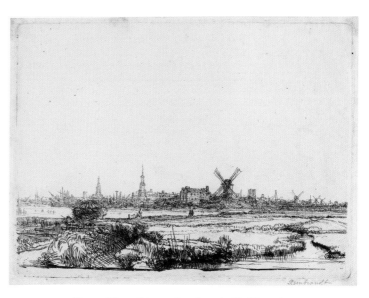

Fig.23 *Death appearing to a wedded couple from an open grave*, 1639, etching and drypoint on laid paper (WA1863.1862)

Fig.24 *View of Amsterdam from the Kadijk*, c.1641, etching on laid paper (WA.Suth.c.1.497.3)

of Rembrandt works. Douce was particularly interested in Northern European art of the Renaissance, particularly fifteenth- and sixteenth-century prints from Germany and the Netherlands. Douce's Rembrandt works reflect his peculiar taste for the divine and the macabre. They include, for instance, Rembrandt's 1638 etching of *Adam and Eve* as it features a remarkable dragon-like serpent, inspired by Albrecht Dürer (1471–1528) [no.**47**]. Similarly, Douce acquired *Death appearing to a wedded couple from an open grave*, befitting his favourite theme of the Dance of Death [figs 23 and 25].

Later additions to the Ashmolean's Rembrandt holdings are smaller and often contain just a single Rembrandt print. Rembrandt's *View of Amsterdam from the Kadijk* from around 1641 [fig.24] was included in the Sutherland Collection, built up by Alexander Hendras Sutherland (1753–1820) and his wife Charlotte (1782–1853) which was gifted to the University in 1837 and transferred to the Ashmolean in 1950. This large collection of almost 20,000 works is comprised of sets of extra-illustrated publications, in which printed books were interleaved with portrait and topographical prints and drawings related to the text. Rembrandt's view of Amsterdam was pasted opposite a page mentioning Amsterdam as the possible location where the Crown Jewels were allegedly sold in 1647 during the English Civil War.

Apart from smaller acquisitions in 1954, 1962, 1999 and as recently as 2008, the largest group of Rembrandt prints (after the Chambers Hall gift) arrived in 1946. This took the form of a bequest of 24 prints from Gaspard O. Farrer through the Art Fund, including an impression of *The Hundred Guilder Print* [no.**31**].

Fig.25 Recto of fig.23, detail with
Francis Douce's collector's mark

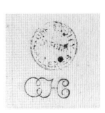

Fig.26 Verso of *Landscape with a Cottage
and Hay Barn*, 1641 (WA1855.266.1).
Detail of verso, collector's mark of
Chambers Hall, Lugt 551

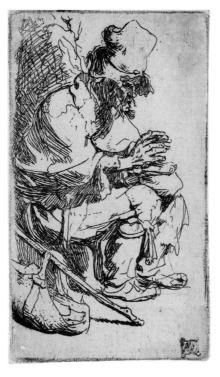

Fig.27 *Beggar seated warming his
Hands at a chafing Dish*, c.1630,
etching on laid paper (WA1855.331)

Fig.28 Verso of fig.26

Fig.29 Verso of no.16 (detail)

While these Rembrandt prints can be solely admired for their intrinsic artistic qualities, closer inspection reveals a number of inscriptions and stamps added by later owners of these prints, including the University of Oxford, which reveal the collecting history or provenance of these works. Rembrandt's prints were widely collected from as early as the 1630s onwards, either sold or given away by Rembrandt himself. Collectors of works on paper often inscribed or stamped the works in their collection with their names, initials and/or the date when they acquired the work, either on the front or on the back of the sheet. Often this was done by collectors with a view to posterity, ensuring a collector's name remained permanently associated with the work and any earlier marks of illustrious former collectors who had owned the same print. These collectors' marks have been catalogued by the Fondation Custodia (founded by Frits Lugt) on their online database, enabling us to trace the collecting history or provenance of the Rembrandt prints at the Ashmolean. This is particularly important for researchers today as many important collections have been dispersed in the course of history.

As mentioned above, the majority of the Rembrandt prints in the Ashmolean came directly from the Chambers Hall Gift in 1855. These all bear a stamp with the initials 'CH' on their verso; often older marks and stamps can be found alongside Hall's stamp, revealing that they once belonged to other important British and Continental collections. Additionally, a stamp of the University of Oxford is seen on most of the Rembrandt prints acquired by the Ashmolean before 1908 when the University Galleries merged with the Museum [fig.26].

For example, the multiple collectors' marks on the front and back of *Beggar seated warming his Hands at a chafing Dish* reveal that this particular print was once owned by the following great collectors of Rembrandt prints: John Barnard (1709–1784), George Hibbert (1757–1837), Heneage Finch, 5th Earl of Aylesford (1786–1859) and finally Chambers Hall himself [figs 27 and 28]. Further examination of the collectors' marks on the prints donated by Chambers Hall reveals that these prints once belonged to other illustrious collections, such as those formed by Pierre Mariette II (1634–1716), William Esdaile (1758–1837), Franz Rechberger (1771–1843), Pierre Rémy (second half of the eighteenth century), John Heywood Hawkins (1802–1877), Edward Astley (1729–1802), among others [fig.30, overleaf]. Interestingly, one of the Ashmolean's prints appears to have once belonged to the notorious art thief Robert Dighton (1751–1814). His handwriting can be discerned on the back of one of the Rembrandt prints, spuriously claiming to have acquired this print from the British engraver and Rembrandt collector Thomas Worlidge (1700–1766) [fig.29].

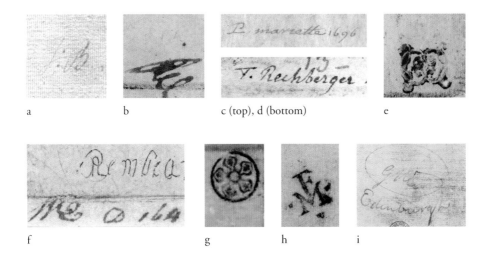

a b c (top), d (bottom) e

f g h i

Fig.30 COLLECTORS' MARKS

a. *Beggar seated warming his Hands at a chafing Dish, c.*1630 (WA1855.331)
 Detail of verso, collector's mark of John Barnard (1709–1784), Lugt 1419
b. *Sleeping Puppy, c.*1640 (WA1855.316)
 Detail of recto, collector's mark of Pierre Remy (1715/6–1797), Lugt 2136
c. *Christ preaching* ('*La Petite Tombe*'), *c.*1657 (WA1855.412)
 Detail of verso, collector's mark of Pierre Mariette (1634–1716), Lugt 1789
d. *Self-portrait open-mouthed, as if shouting: bust,* 1630 (WA1855.319)
 Detail of verso, collector's mark of Franz Rechberger (1771–1843), Lugt 2133
e. *Beggar seated warming his Hands at a chafing Dish, c.*1630 (WA1855.331)
 Detail of recto, collector's mark of George Hibbert (1757–1837), Lugt 2849
f. *Beggar Woman leaning on a Stick,* 1646 (WA1855.343)
 Detail of recto, collector's mark of William Esdaile (1758–1837), Lugt 2617
g. *Plate 3: David and Goliath,* 1655 (WA1855.313.3)
 Detail of recto, collector's mark of Edward Astley (1729–1802), Lugt 2774
h. *The Ringball Player* ('*Het Klosbaantje*'), 1654 (WA1855.384)
 Detail of recto, collector's mark of Martin Folkes (1690–1754), Lugt 1034
i. *Lieven Willemsz. van Coppenol, Writing-Master, c.*1658 (WA1855.289)
 Detail of verso, collector's mark of George Walker (active 1781–1815), Lugt 1224

FURTHER READING

C. Ackley and T. Rassieur, *Rembrandt's Journey: painter, draughtsman, etcher*, exhibition catalogue (Museum of Fine Arts, Boston and The Art Institute of Chicago), Boston, 2003.

A. Bartsch, *Catalogue raisonné de toutes les estampes qui forment l'oeuvre de Rembrandt et ceux de ses principaux imitateurs*, 2 vols., Vienna, 1797.

A. Eeles, *Rembrandt Prints 1648–1658: A Brilliant Decade*, exhibition catalogue (Robert and Karen Hoehn Family Galleries, University of San Diego), San Diego, 2015.

R. Fucci, *Rembrandt's changing impressions*, exhibition catalogue (The Miriam and Ira D. Wallach Art Gallery, Columbia University NY), New York, 2015.

E.F. Gersaint, *Catalogue raisonné de toutes les pièces qui forment l'oeuvre de Rembrandt*, Paris, 1751.

A. Griffiths, *Prints and Printmaking*, London, 2004.

A. Griffiths, *The Print before Photography*, London, 2016.

A.M. Hind, *A Catalogue of Rembrandt's Etchings*, 2 vols, London, 1923.

E. Hinterding, *Rembrandt as an etcher*, 3 vols, Ouderkerk aan den IJssel, 2006.

E. Hinterding, *Rembrandt Etchings from the Frits Lugt Collection*, 2 vols, Bussum-Paris, 2008.

E. Hinterding, G. Luijten and M. Royalton-Kisch, *Rembrandt the Printmaker*, exhibition catalogue (Rijksmuseum, Amsterdam and The British Museum, London), London, 2000.

E. Hinterding and J. Rutgers, *The New Hollstein Dutch & Flemish Etchings, Engravings and Woodcuts 1450–1700: Rembrandt*, 7 vols, Ouderkerk aan den IJssel, 2013.

F. Lugt, *Les marques de collections de dessins & d'estampes*, online edition by the Fondation Custodia, consulted 18 March 2019: http://www.marquesdecollections.fr.

C. Rümelin, *Rembrandt Fecit: Grafiikkaa – Prints*, exhibition catalogue (Retretti Art Centre, Punkaharju), Oxford, 2004.

J. Rutgers and T.J. Standring, *Rembrandt: Painter as Printmaker*, exhibition catalogue (Denver Art Museum), New Haven, 2018.

N. Stogdon, *A descriptive catalogue of the etchings by Rembrandt in a private collection Switzerland*, s.l., 2011.

C. White, *Rembrandt as an Etcher*, London, 1999.

C. White and K. Boon, *Hollstein's Dutch and Flemish Etchings, Engravings and Woodcuts, Volumes XVIII–XIX: Rembrandt van Rijn*, Amsterdam, 1969.

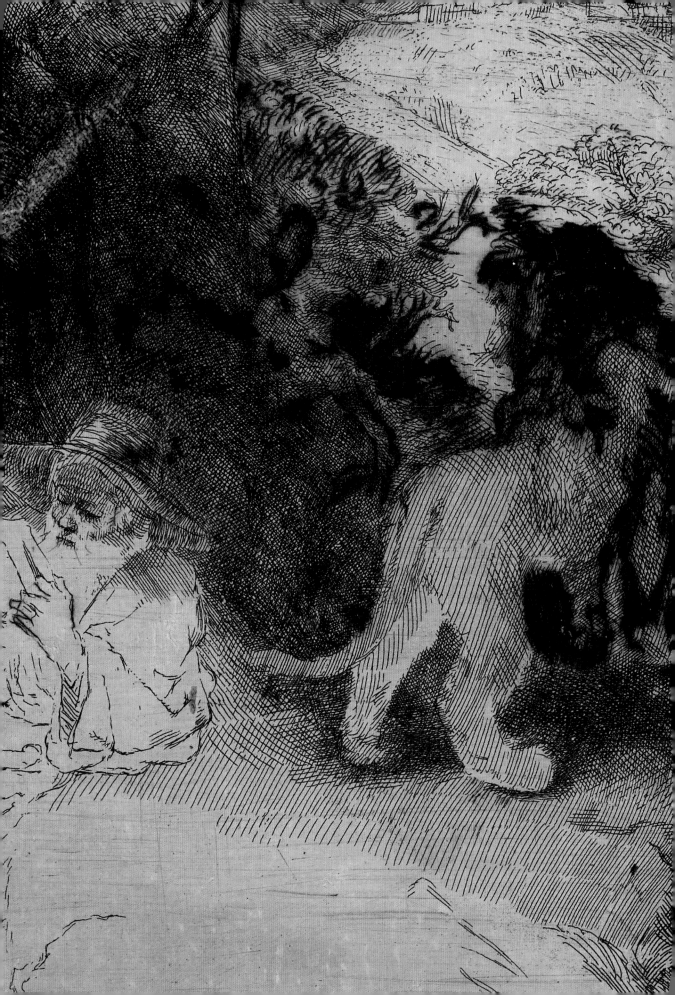